AROUND HOCKLEY

THROUGH TIME

Ted Rudge *&* John Houghton

AMBERLEY PUBLISHING

First published 2010

Amberley Publishing Plc
Cirencester Road, Chalford,
Stroud, Gloucestershire, GL6 8PE

www.amberley-books.com

Copyright © Ted Rudge & John Houghton, 2010

The right of Ted Rudge & John Houghton to be
identified as the Authors of this work has been
asserted in accordance with the Copyrights, Designs
and Patents Act 1988.

ISBN 978 1 84868 136 1

British Library Cataloguing in Publication Data.
A catalogue record for this book is available from
the British Library.

Typeset in 9.5pt on 12pt Celeste.
Typesetting by Amberley Publishing.
Printed in the UK.

Foreword

Hockley takes its name from the brook which forms its northern boundary and which separated the manor of Birmingham from the manor of Handsworth and Lozells, part of the manor of Aston. Now culverted, the stream used to run openly south eastwards from Rabone Lane by the Smethwick Gas Works, past Gib Heath and over Factory Road. From there it went along the old tramway depot off Whitmore Street, along the top end of Farm Street and through Lozells to cross Summer Lane by its junction with Alma Street – by which place it had become known as the Aston Brook.

Rising either side of the brook were a number of banks, including Hockley Hill. From the beginnings of Brum, the road to Wolverhampton went across this slope and from 1727 it was maintained by a turnpike trust. It was an essential route down which came the fuel so crucial to Birmingham's industries. But the 'one grand Obstacle to the carriage of Coals on that road has been the Sands or Ice at Hockley Brook, and the Ascent there from'. Accordingly in 1764 a subscription list was started to raise funds to erect a bridge over the stream and lower the hills on either side.

Stretching from the Summer Lane neighbourhood in the east to Brookfields in the west, Hockley was the largest district in the old manor of Birmingham. Lying distant from the village which grew up around Saint Martin's Church, it was outside the urban sway of Birmingham until the late eighteenth century. Indeed, apart from the Newhall Street neighbourhood, it is not shown on the five earliest maps of the town. Similarly, most of Lee Bank, Winson Green, Rotton Park, Ladywood and Spring Hill are excluded. These omissions stress the lack of population in these areas.

The first plan to include all them was the Street Commissioners map of 1810. This showed that much of the Jewellery Quarter had been laid out by the Colmores and that development had begun to lap up Constitution Hill and along Great Hampton Street. Fifteen years later, Pigott Smith's added more detail. To the north of Warstone Lane were many small gardens on land owned by Sir Thomas Gooch and Colonel Vyse. Hockley Street, Spencer Street, Branston Street and Key Hill were the only indications of building in this vicinity. Nearby, Lodge Road was obvious running through 'a pleasant valley' – on the one side of which was Hockley Pool and on the other the estate of the mock Hockley Abbey.

Coming from town, on Constitution Hill stood the large papier maché works of Jennens and Betteridge; whilst William Hawkes Smith described Great Hampton Street as 'a wide, untidy-looking, irregular range of middling houses; but at the farthest end, an interesting prospect presents itself, over a well-varied country'. Standing on Hockley Hill, he could pick out both Barr Beacon and Aston Parish Church. To the east of Great Hampton Street, the Summer Lane neighbourhood had reached Hospital Street – although Tower Street did strike out further to Great Hampton Row. The other streets on this side of Hockley were Bond Street, Little Hampton Street, Barford Street and part of Hockley Street. They boasted few buildings and most of the land was small gardens – although there were a number of large fields between the future New John Street and the Hockley Brook.

Apart from a small section of land owned by Colonel Vyse and through which would be cut Mott Street, the whole of east Hockley was owned by Caroline Colmore. Her property was transformed within a decade. By the mid 1830s, Hockley Hill had been reached by New John Street, from which a host of smaller streets had been cut on the town side. Within another ten years, roads had also begun to strike out northwards and by the 1850s the only reminder of the countryside was the name of Farm Street. Will Thorne founded the Gas Workers' Union in the 1880s and later became Labour MP for West Ham. He was born in Farm Street in 1857 and wrote that he had 'no memories of the free air of a farm during those early far-off days; just the ugly houses and cobbled neglected streets that were my only playground for a few short, very short years'.

Across on Key Hill, the rest of Colonel Vyse's Estate was cut out by the time of Thornes's birth – with the aptly-named Vyse Street as its focal point; whilst two cemeteries occupied the lower parts of the slope. Similarly, Hockley Abbey had been demolished and Heaton Street and others occupied its site. The east side of Hockley was dominated later by the Lucas factory, itself now a memory. The district's houses were knocked down in the 1950s and 1960s. With the Summer Lane neighbourhood, this eastern part of Hockley was called Newtown and was covered with high-rise flats and other council dwellings. Today, the name Hockley has shrunk to cover mostly the Jewellery Quarter and the lower reaches of Lodge Road. Perhaps it is time for Hockley to reclaim its former extent.

This Hockley book is important for capturing not only the past but the present and ensuring that neither will be forgotten in the future. I congratulate Ted Rudge and John Houghton on their achievement.

Professor Carl Chinn MBE

Introduction

This book has been compiled by two friends who have a profound interest in the history of old and new Birmingham. One friend Ted Rudge was born in the same Winson Green street that June the wife of the other friend John Houghton was also born; they knew each other's family from a very young age. Individually Ted and John have each built and continue to run successful websites devoted to areas either side of Hockley they being Winson Green to Brookfields and Aston. Although they both knew old Hockley very well, John through working and walking to and from when courting and Ted through the years he spent as a telegraph messenger racing around the Hockley streets on a motor bike. Each chose to photograph and compare the portion of Hockley that borders their own individual website.

Hockley had a considerable number of industrial premises that employed their workforce not only locally but from all over the Midlands especially within the world famous Jewellery Quarter and the world wide Joseph Lucas electrical empire. So many Lucas employees finished their working day at the same time that Birmingham City Transport lined special busses up outside the various Hockley works to help them on their way home. The Hockley homes workers and their families lived in were mostly from another century. These homes included the back-to-back terraces where families lived in courtyards sharing the domestic washing and toilet facilities with each other. Living so close together communities were forged where families socialised in local public houses and shopped daily in local shops that sold most things; there was at least one shop or pub on every street.

Redevelopment changed this way of living. Most changes occurred largely where housing with congested basic facilities and living conditions dating from the nineteenth century existed. Families were re-housed and the old properties demolished, large open spaces have been provided and tree lined street are now occupied by modern housing and a few high rise flats. Industry however started to decline in Hockley around the same time as the redevelopment began resulting in the eventual loss of big employers like Joseph Lucas, W. Canning & Co and The Birmingham Mint. Fortunately the Jewellery Quarter reinvented itself and is now a thriving retail and manufacturing centre still employing large numbers.

Most of the above and more have been captured in the photographic journey this book provides around Hockley beginning at a very familiar landmark the Chamberlain Memorial Clock in the Jewellery Quarter and continues in roughly an anticlockwise direction finishing back at the Jewellery Quarter. It has not been possible to include every change that took place in Hockley but what roads, places, buildings, living conditions and places of work that have been included should be of enough interest to evoke memories of the parts not included. Please enjoy the read and we hope the nostalgia rekindles many thoughts you have or had of your past or present involvement in Hockley.

Ted Rudge MA and John Houghton

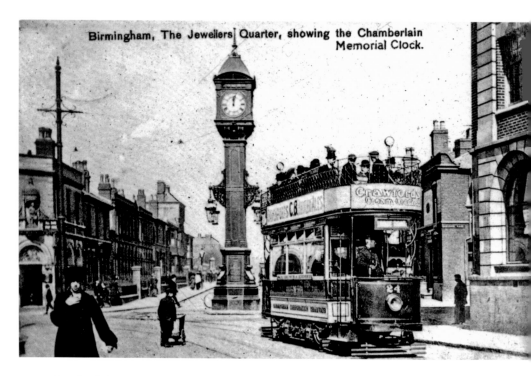

Birmingham, The Jewellers Quarter, showing the Chamberlain Memorial Clock.

Chamberlain Memorial Clock

An open top public transport tram on its way to Birmingham City centre having just passed the Chamberlain memorial clock. The clock has stood on a small island at the junction of Warstone Lane, Vyse Street & Frederick Street in the world famous Jewellery Quarter since 1903. The Rt. Hon. Joseph Chamberlain MP was Mayor of Birmingham between 1873-5. Today at this busy junction people gather waiting for a break in the traffic before attempting to cross Frederick Street on route to Warstone Lane.

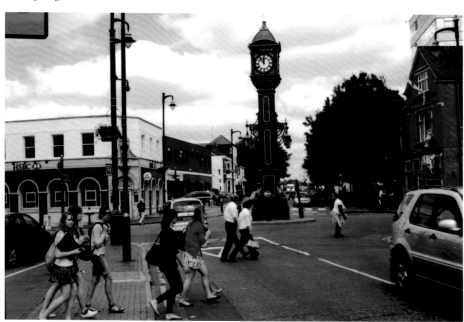

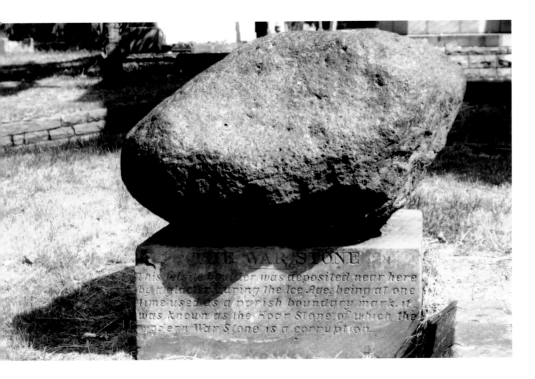

The War Stone

Located on a stone plinth to the left of the Warstone Lane Cemetery Lodge is the War Stone. Etched into the stone are the following words; This felstone boulder was deposited near here by a glacier during the Ice Age being at one time used as a parish boundary mark. It was known as the 'hoar stone' of which the 'war stone' is a corruption. Two cemeteries exist in Hockley around the Jewellery quarter. Warstone Lane Cemetery, now closed for any new internments, dates from 1847 and is situated in Warstone Lane – Vyse Street – Pitsford Street and Icknield Street.

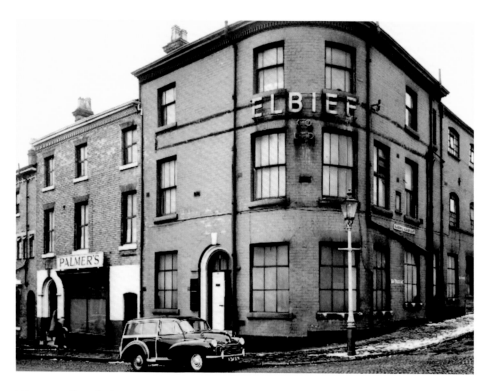

Warstone Parade East

On the junction of Warstone Lane and Warstone Parade East is a classic example of building reuse. The old Elbief premises a Grade II listed building has been converted from industrial use to domestic and is now called The Minories containing many apartments.

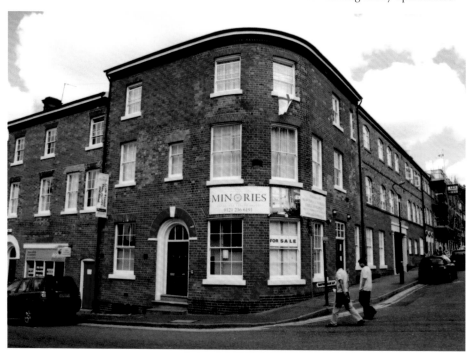

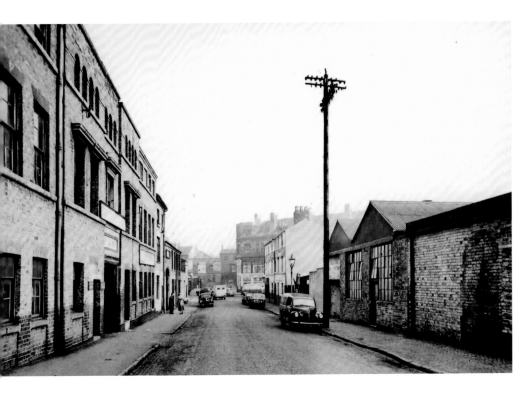

Camden Street

Steps that lead up to a doorway raised well above ground level feature in part of this old building, probably as built, contrasting greatly with the new industrial units across the road. Camden Street has always been a long street that is divided by Icknield Street with one part in Brookfields and this part in Hockley that leads to The Parade.

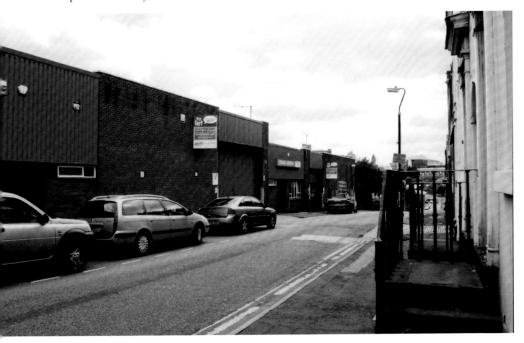

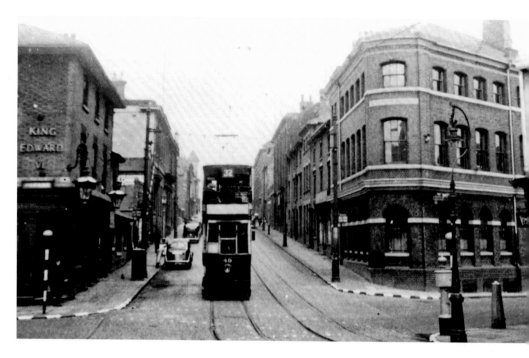

Newhall Hill and Frederick Street

Five roads converge at this busy junction seen here with a tram descending one of them, Newhall Hill, were in 1832 Thomas Attwood held the famous chartist meeting attended by over 200,000 people. At the top end of Newhall Hill the tram would have travelled along Frederick Street where the street name sign is fixed to the wall of The Argent Centre that houses the Penroom Museum. This Italian style building built of black, red and white bricks in 1863 for a pen manufacturer once had a Turkish bath incorporated.

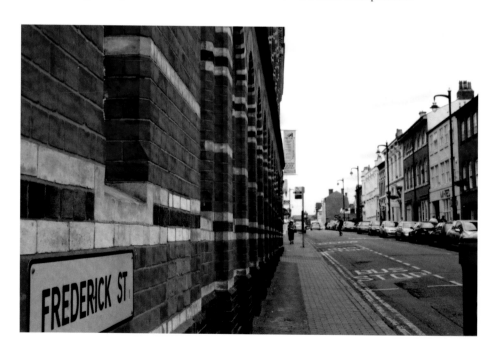

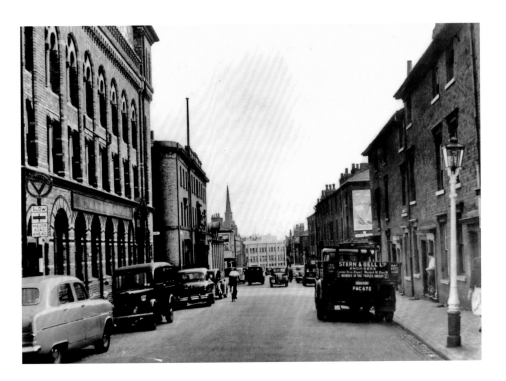

Graham Street

Working class houses on the right hand side of Graham Street have been replaced by a car park and modern industrial units. The steeple of St Pauls Church can be seen in the distance and another historical building on the right just past the car park was once the Mount Zion Chapel that opened in 1824. For two years 1844-1846 George Dawson's ministry made this chapel one of the most successful in Birmingham. Over the years the building has been used by many faiths the current being as the "Ramgarhia Sikh Temple".

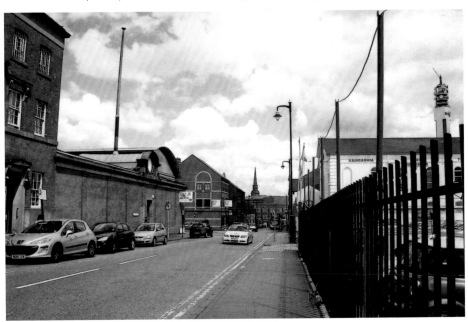

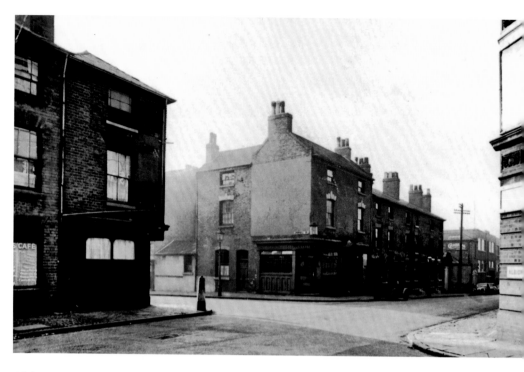

Albion Street

Redevelopment at the crossroad where Albion Street crosses Camden Street and becomes Powell Street has removed the mid nineteenth century housing together with the local public house and back street shops. Together they once formed a local community that worked in nearby factories or workshops in the Jewellery Quarter.

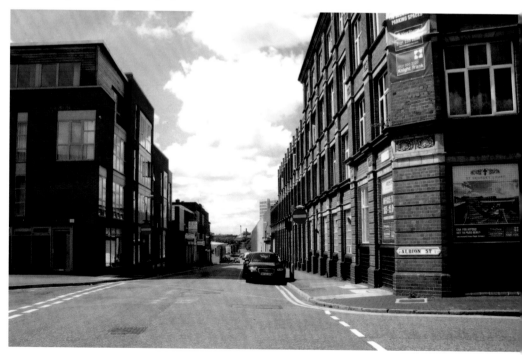

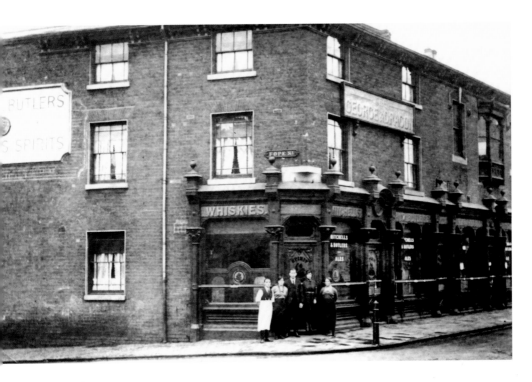

George and Dragon

Encased in scaffolding the George and Dragon public house on the corner of Pope and Albion Streets looks set to receive a renewed future. Spanning part of Carver Street and Legg Lane at the far end is the old Albion Street Fire Station no longer in use for that purpose. Currently the old station is used as a children's nursery/play area.

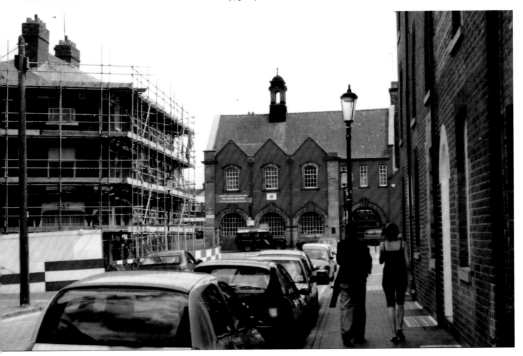

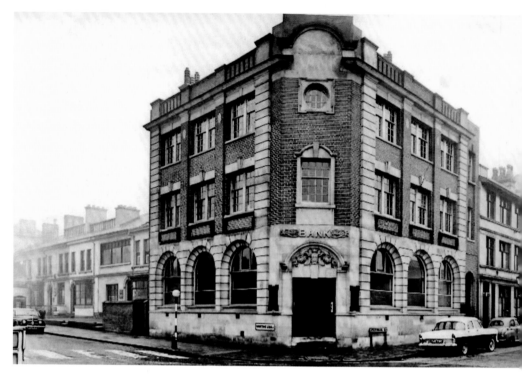

Warstone Lane

On the corner of Frederick Street and Warstone Lane is an impressive bank building that still operates much the same as when it was first built. The same can be said for most of the other nearby buildings all serving a purpose in the production or selling of jewellery.

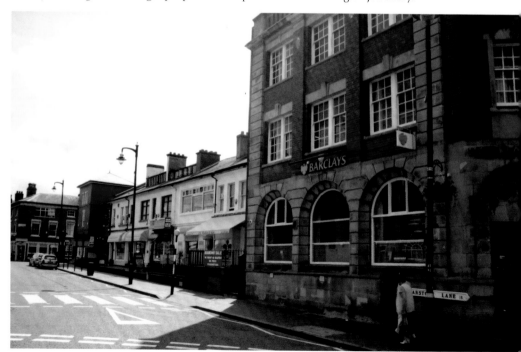

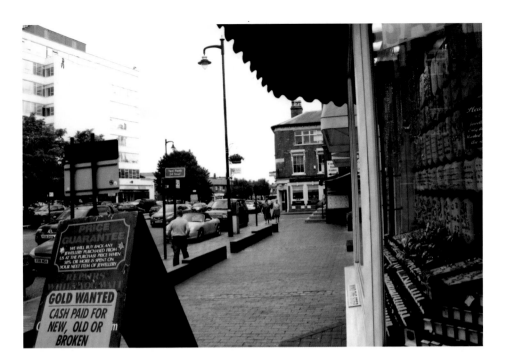

The Big Peg

In both photographs the large white building, built in the 1960s and originally called the Hockley Centre, was later re-named to The Big Peg after the jewellers' workbench. The building dominates the early part of Warstone Lane and stretches through to Vyse Street. Main purpose of the building is to accommodate a large number of manufacturing jewellers and other jewellery associated trades who originally would have worked from small poorly lit workplaces. Across Warstone Lane shop windows are packed with items of jewellery for sale and the old post office juts out at the start of Victoria Street.

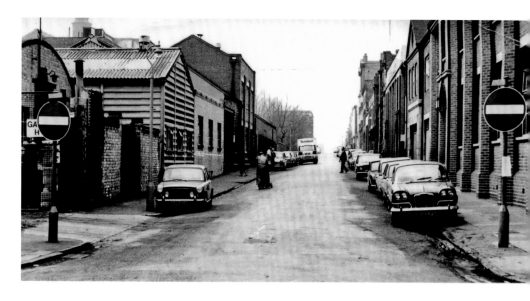

St Pauls Church

The church spire overlooks the factory buildings that absorb all of Cox Street, a small street that joins the Georgian 'St Pauls Square' with the church in the centre. Roger Eykyn designed the body of the church built between 1777 and 1779 and the spire designed by Francis Goodwin was not added until 1822/23.

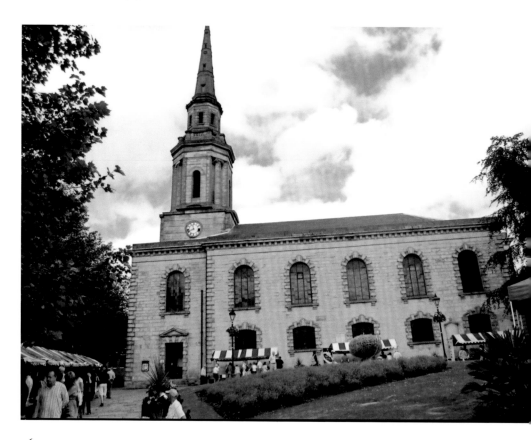

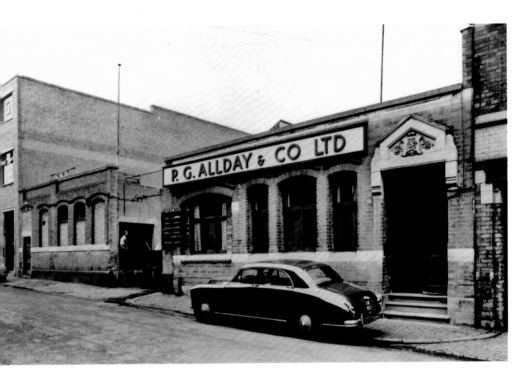

Kenyon Street Factories
Some older industrial buildings in Kenyon Street have been replaced by modern buildings units. Kenyon Street once housed the headquarters of Birmingham City Police force C division until the 1970s.

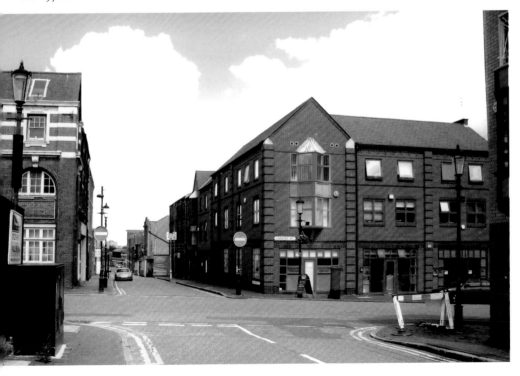

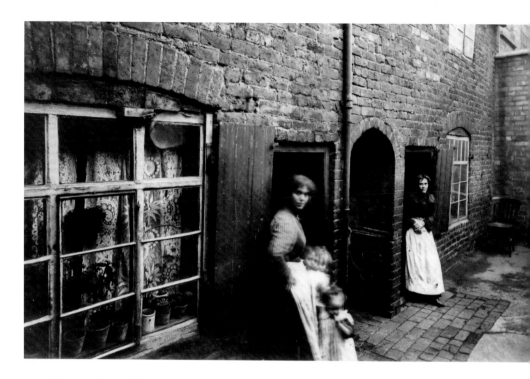

Kenyon Street Houses

Back-to-back housing dominated the inner city districts of Birmingham until the 1960s when the areas were redeveloped under various redevelopment schemes. The courtyard scene dating probably from the early 1900s displays the condition, often unsanitary, that most working class families had to endure prior to demolition. Today Kenyon Street is occupied only by old and new industrial buildings.

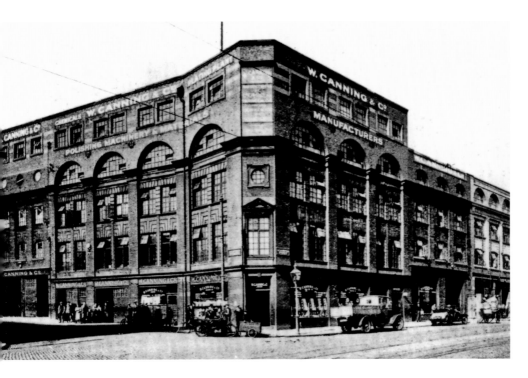

W. Canning & Co

A large impressive building between Kenyon Street and Hall Street fronted Great Hampton Street and was once occupied by W. Canning & Co the specialist chemical manufacturing company. This building has been demolished whereas others of the same stature locally have survived. The old photograph shows the building occupied by W. Canning & Co and new one the corner of Kenyon Street where it once stood.

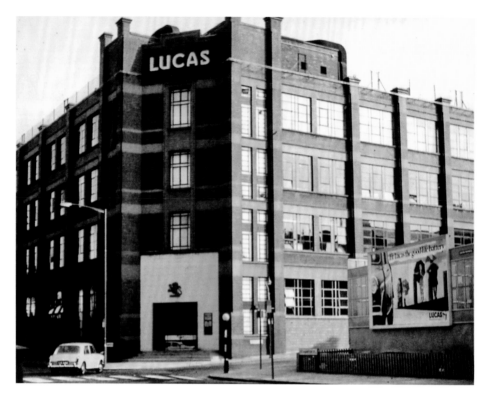

Lucas Great Hampton Street
New Hampton Lofts domestic apartments now occupy the former Joseph Lucas building on the corner of Hockley Street and Great Hampton Street. Many thousands of workers were employed in the Hockley area at various Lucas buildings this being one of them.

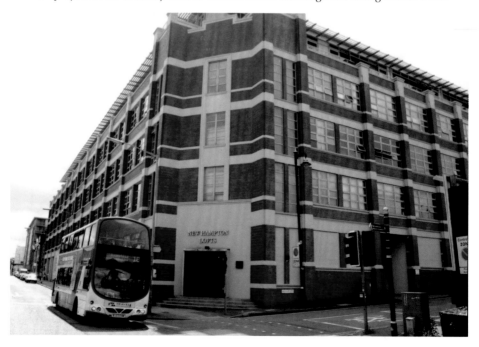

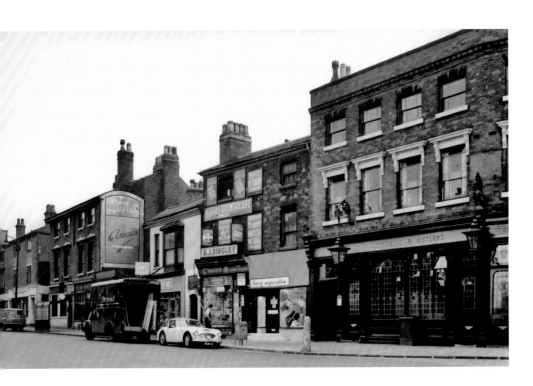

Hockley Hill (Town End)

Buildings along this part of Hockley Hill do not appear to have altered much – only their usage. Ansells and Mitchells & Butlers two of the largest brewers in the Midlands had public houses almost side by side The Trees Inn and Duke of York. The area's industry and the redevelopment caused the customers to move and consequently they no longer serve drinks on this part of Hockley Hill.

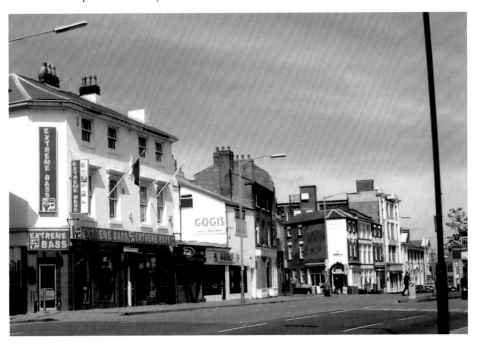

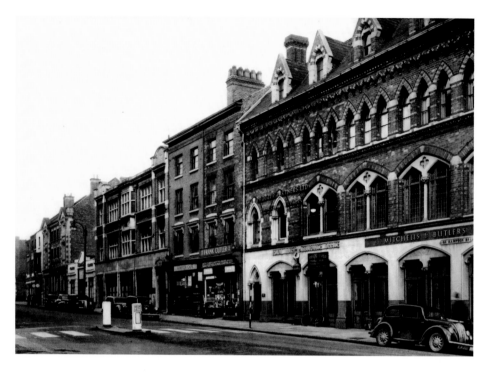

Great Hampton Street

In the early photograph on the corner of Great Hampton Street and Great Hampton Row stood a magnificent public house, built in early 1900s in a Gothic style and named the Gothic, it stands three stories high and supports numerous windows. This side of Great Hampton Street has not been redeveloped and many of the old buildings are as built only a change of usage is evident. On the other side of this road some new buildings have replaced the older ones whilst others have only been modernised.

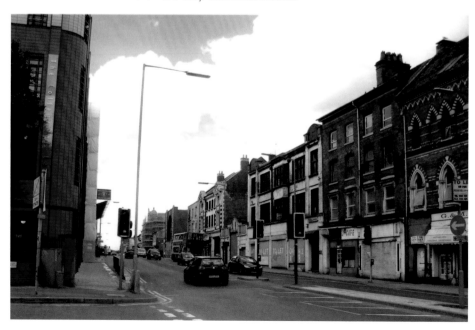

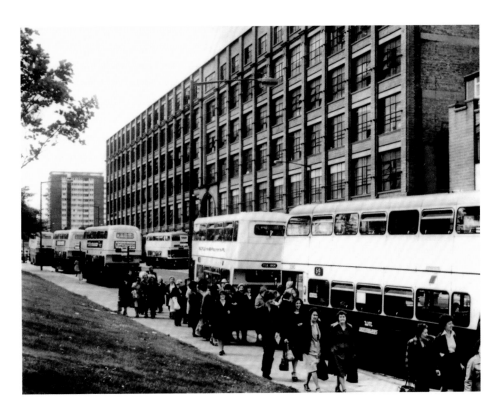

Lucas Great Hampton Row

Joseph Lucas employees seen boarding the Birmingham Corporation buses that are lined up waiting to take the workers home to their part of Birmingham and beyond after a day's work. Now a busy island on a dual carriageway exists replacing the Lucas building now the workers are no longer needed.

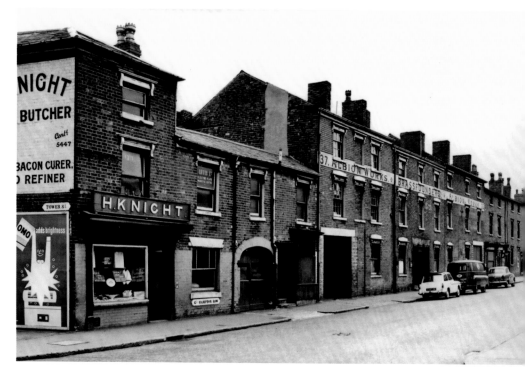

Great Hampton Row

Great Hampton Row was a thoroughfare consisting of several factories and many old houses dating from the Victorian period with Tower Street running off. This area now is known as St George's Community Hub with a children's nursery named after the local church St George's which was demolished in 1960.

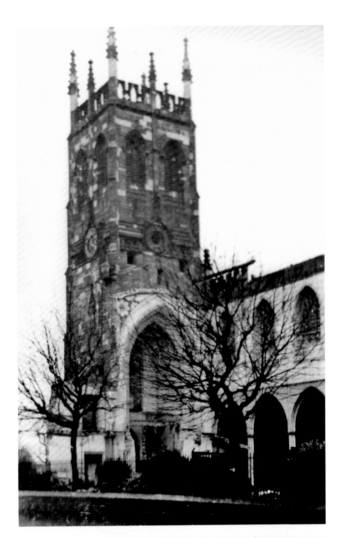

St George's Church

St George's Church designed by Thomas Rickman was consecrated in 1822 and demolished in 1960. The site of the old church and grounds is now called St George's Park, at the center of the park Thomas Rickman's memorial can be located and round the parks enclosure old grave stones have been placed.

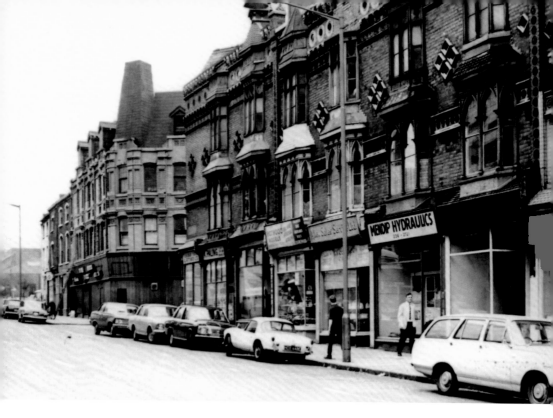

Constitution Hill

Constitution Hill is part of the main road that runs from Birmingham City centre towards West Bromwich passing through Hockley and Handsworth. Some old buildings remain with refurbishment being carried out. The Cedar club an early Birmingham night club has disappeared between the two photographs and many of the shops have stopped trading.

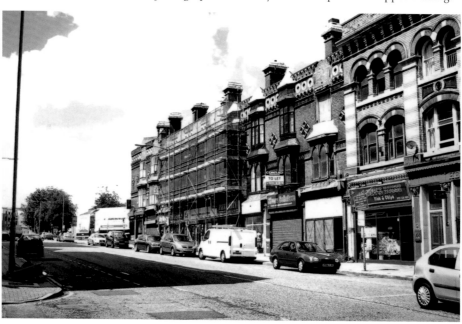

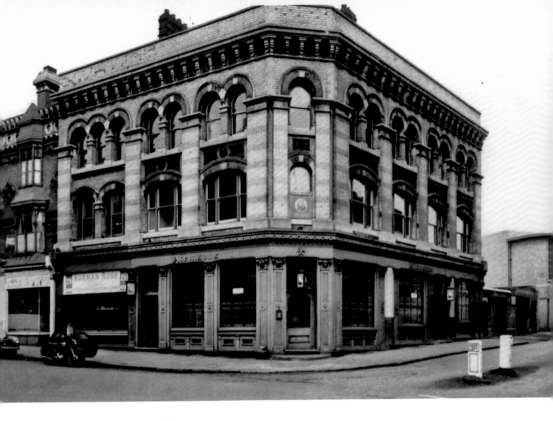

Constitution Hill (Town End)

Another outstanding Hockley building is the public house on the corner of Constitution Hill and Henrietta Street. The Hen and Chickens has most likely been trading since the early Victorian times. Now at a point in time when many public houses are closing this one is still serving customers, the building appears unchanged except for the addition of a satellite dish.

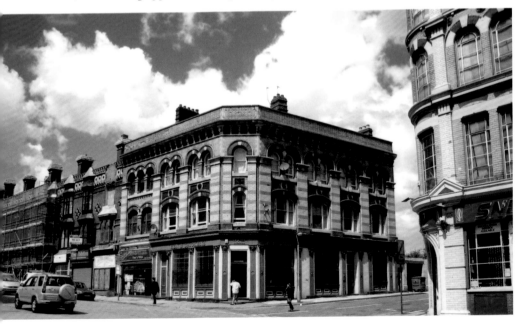

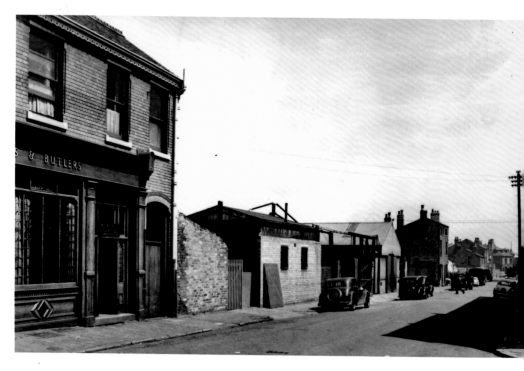

Cecil Street

Cecil Street was once a thriving community of back-to-back terraced houses situated right next to factories, shops and the local pub. Today, Cecil Street, following the demolition and restructuring that has occurred in the area is today a much shorter street than previously.

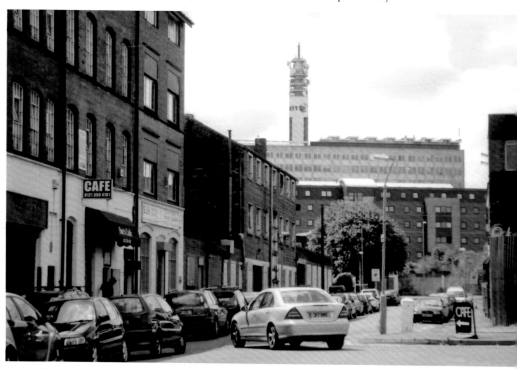

Summer Lane

Summer Lane forms the boundary between Hockley, Newtown and Aston. British Telecom (BT) tower is overlooking the Summer Lane back-to-back houses that are well past their best and soon to be demolished making way for industrial units to be built. Children are seen playing in the lane in the early photograph but now due to the amount of traffic generated delivering to the new factory units this no longer takes place.

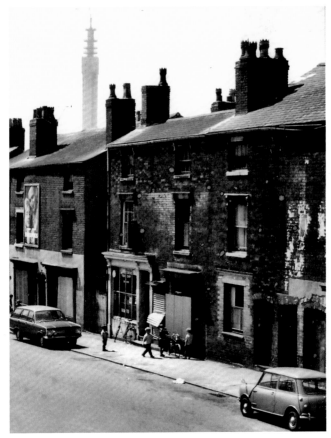

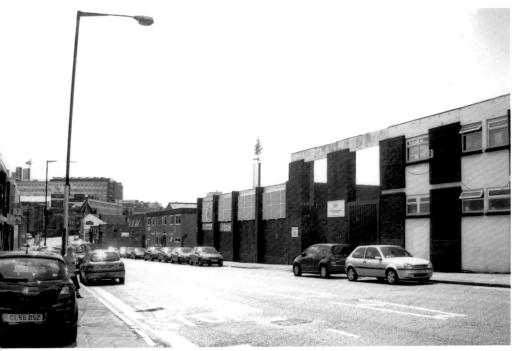

29

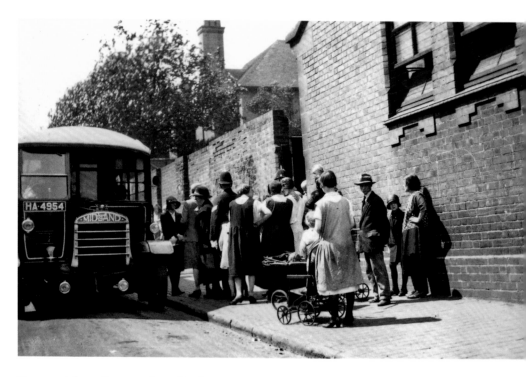

Transport from Summer Lane Settlement

Camps were organised for boys and girls from the Birmingham Settlement which was located on the corner of Summer Lane and Tower Street. One summer's day in August 1939 a police sergeant and a police constable are seen supervising the boarding onto transport that would take them to the annual camp somewhere in England.

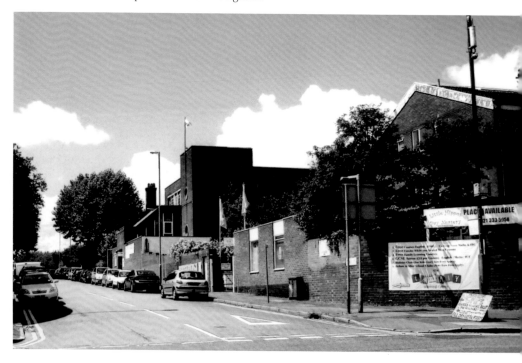

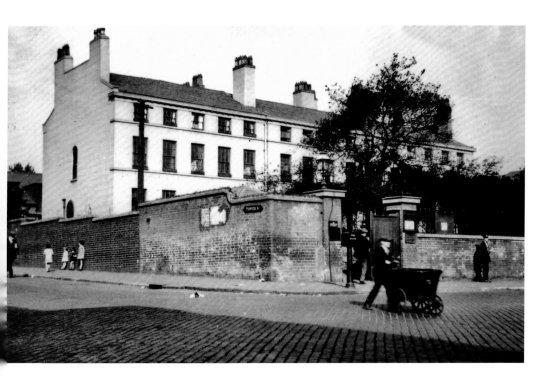

Summer Lane Settlement

The Birmingham Settlement was started by a group of women from Edgbaston in 1899; it was initially known as the Women's Settlement but changed to the Birmingham Settlement in 1919. At first it was a women's only establishment a place where the poor and destitute could find comfort living in the big house shown in the early photograph. On the corner of the two roads in front of the open gate note the fire alarm from another era no mobile phones then. The big house was demolished and another was built on the site, the Birmingham Settlement left Summer Lane and now operates from Alma Buildings, Newtown.

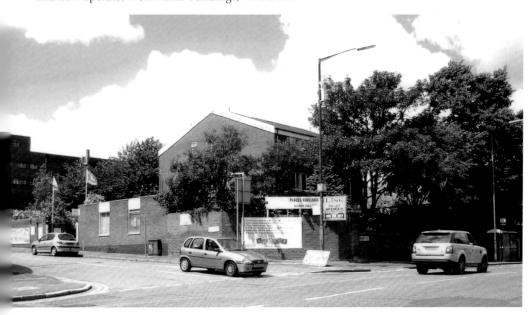

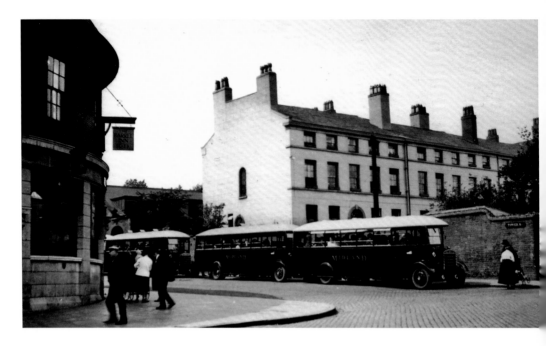

Midland Red outside the Settlement

Three Midland Red single decker transport vehicles are lined up at the side of the Birmingham Settlement about to take a large party of under privileged locals on a journey away from Hockley probably to the countryside or the coast. On the other corner in both photographs is The Barrel public house one of the few in the area from the past that is still open for business.

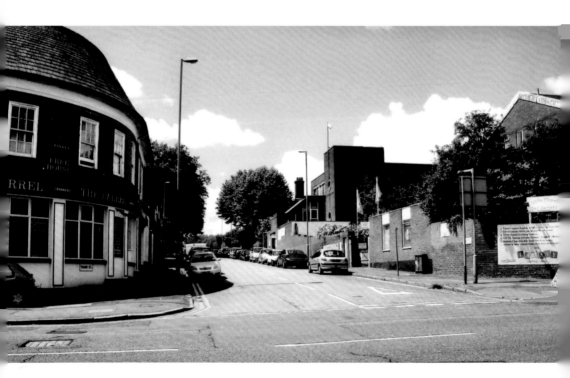

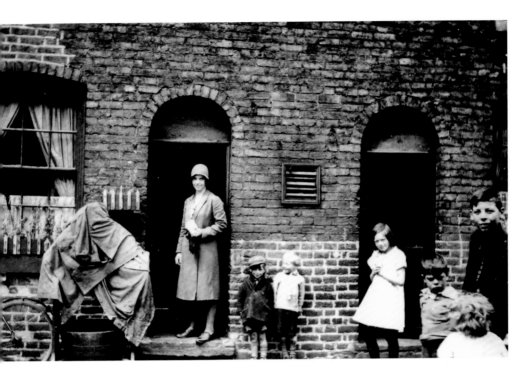

Brearley Street Collection

The Provident lady an agent from the company of the same name is collecting money for goods paid by instalments from the family at 1/89 (number one back of number 89) Brearley Street (houses that were at the rear). Note the wringer also known as the mangle is protected from the elements; these houses are in a communal courtyard were a number of other houses were also located. Now the overcrowded housing has given way to high rise flats in tower blocks and modern houses with communal grassed areas.

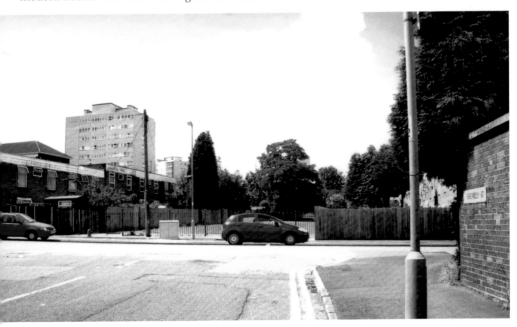

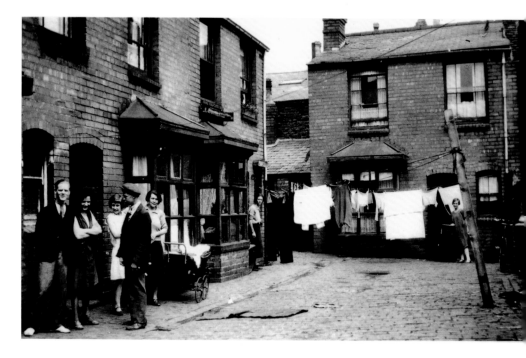

Brearley Street Back-to-Backs

Another crowded courtyard of back-to-back houses, the tenants are posing for the photograph at the back of number 39 Brearley Street. Between the houses the lavatory (toilet) and brewhouse (washing facility) are just visible they were shared by all the tenants of the courtyard and the families in houses at the front. The washing facilities were shared each family having their own wash day. Again the houses have all gone and have been replaced by industrial units.

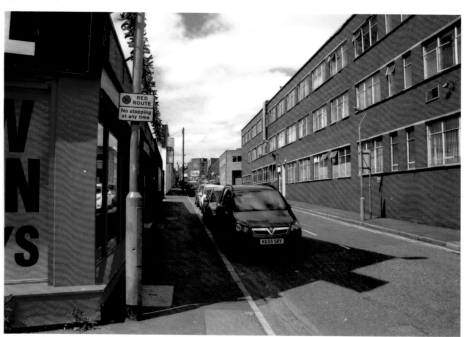

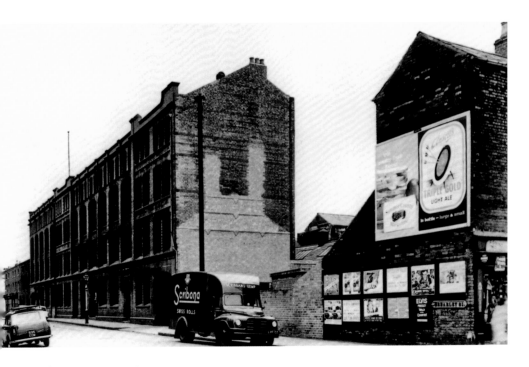

Brearley Street Factories

Brearley Street was a mixture of working class housing, factories, back street shops and public houses; now most of this area consists of industrial units and the rest is covered by a large green open space known as Brearley Park. With Summer Lane in the distance the later photograph reveals the extent of Brearley Street today.

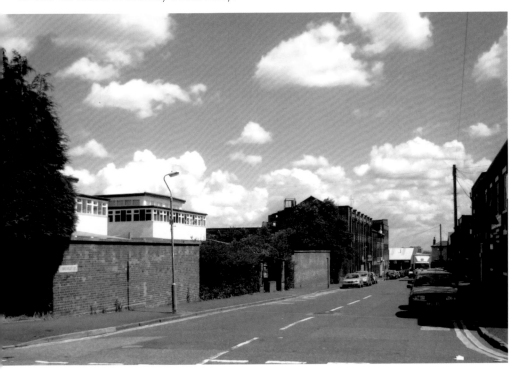

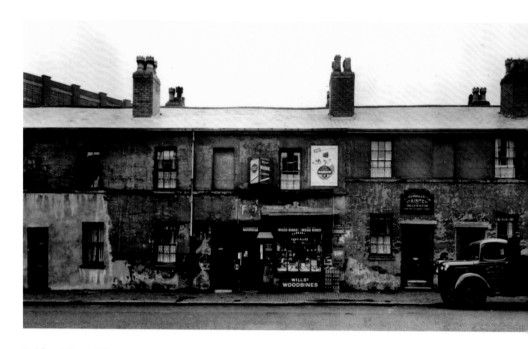

Bridge Street West

Overlooked by the Joseph Lucas factory this row of houses in Bridge Street West, in a poor state of decoration, ironically had Caswell & Son decorator among them. A shop selling general items that the housewife was able to purchase often on the slate (settle up on pay day). The vehicle parked in the street Frank Grounds Motor Services was a well known Birmingham company. Today this part of Bridge Street West is now a cul-de-sac with the new St George's Church at the far end replacing the old church now demolished.

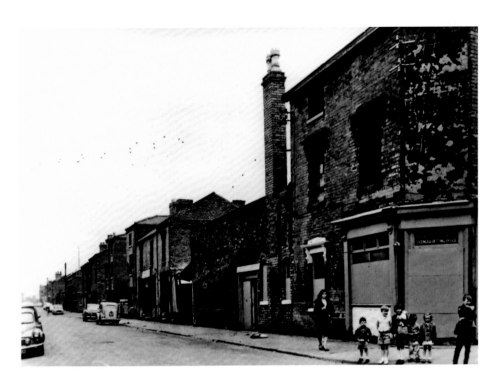

Frankfort Street

Frankfort Street once had many different types of housing; factories included wire works, bicycle works, woodworking and whistle makers. Now the modern housing on the left have trees growing in their gardens together with new factories on the right hand side, the street is only half the original length.

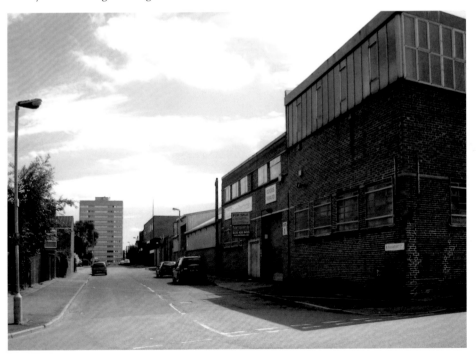

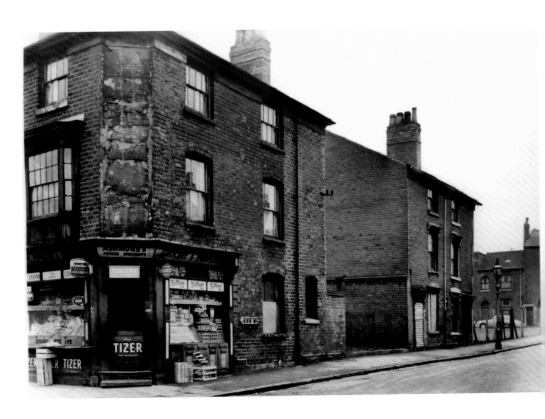

Gee Street

No factories were built in Gee Street a small street off Frankfort Street shown in the early photograph looking towards Frankfort Street. Following the demolition of Ashmore's corner shop and the rest of the old houses in Gee Street a new residential appearance has emerged when looking towards Summer Lane.

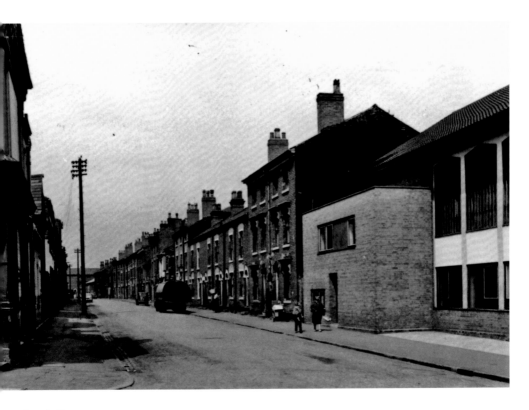

Geach Street

Geach Street is located at the point where Summer Lane meets Alma Street. The 2010 photograph is of Geach Street facing towards Summer Lane and the older one the opposite way. All the old properties have been replaced with modern homes that have gardens and parking places

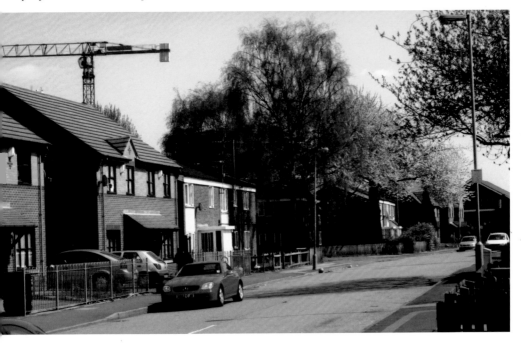

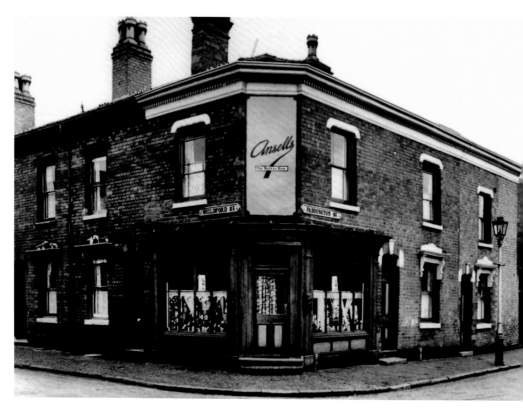

Guildford Street & Paddington Street

An Ansells brewery off-licence/outdoor served the local people of Guildford Street and Paddington Street to alcohol beverages before the days when it became freely available in supermarkets and shops. Now a complete contrast exists with the old houses and outdoor removed following the redevelopment in the 1960s.

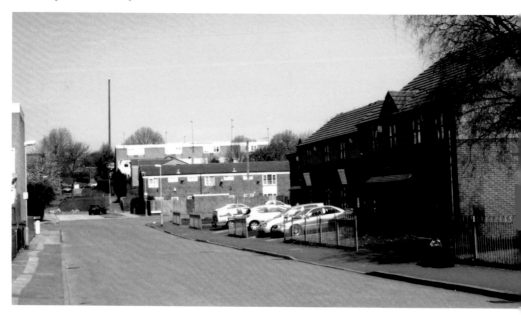

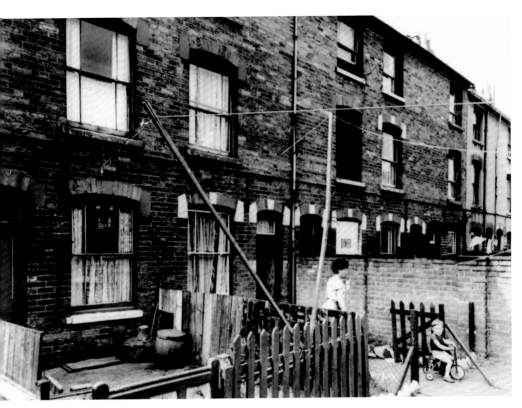

Guildford Street Back-to-Backs
Redevelopment demolished thousands
of back-to-back properties in this and
adjoining streets. Most of the old
properties date from the middle of the
nineteenth century like the one in the
older photograph. High rise tower blocks
provide modern accommodation for
some re-housed tenants.

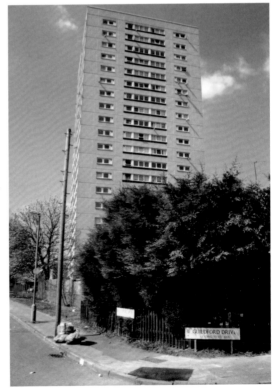

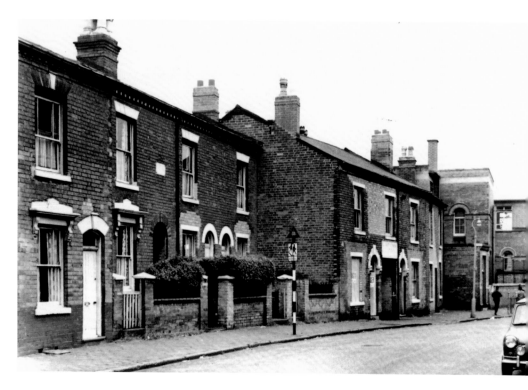

Guildford Street

The infrastructure of the area has changed so much it is difficult to visualise the location of certain old roads. However a clue of the previous road name can be seen in the displayed road sign, Guildford Drive.

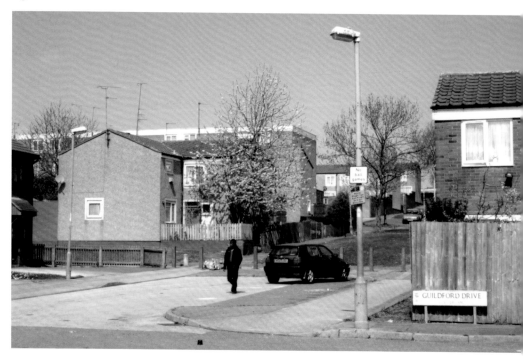

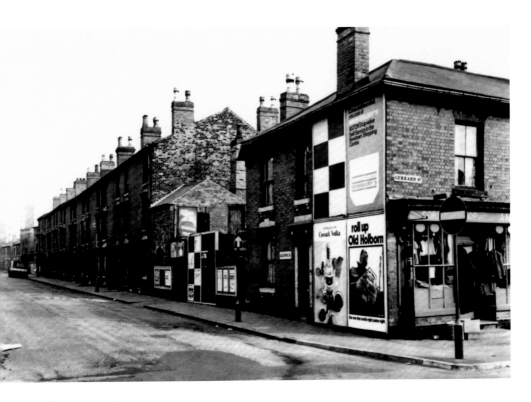

Guildford Street Area

Before redevelopment Farm Street ran from the Hockley Brook to Summer Lane with three roads leading off all were up a gradual incline. They were Wheeler Street, Guildford Street and Lennox Street now only Wheeler Street exists. A second-hand clothes shop displays its wares on the corner of old Guildford Street and Gerrard Street. Today all the Victorian working class housing has gone and replaced by modern social housing.

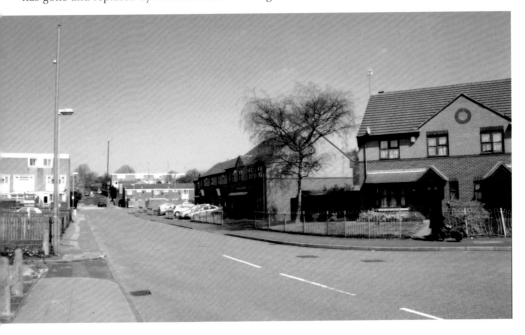

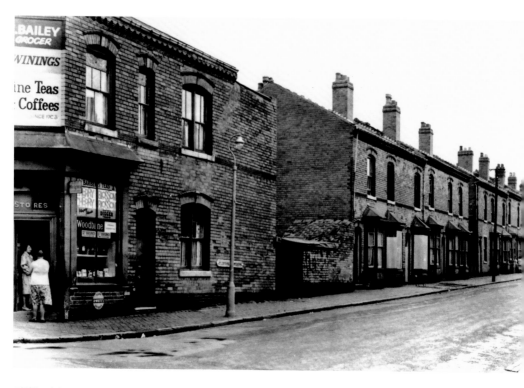

Clifford Street

Clifford Street was another that used to run across Wheeler Street, Lennox Street and Guilford Street. Two ladies find time to talk on the steps of the local grocery shop belonging to E. Bailey. A school now occupies most of Clifford Street shown here with the tree-lined Wheeler Street.

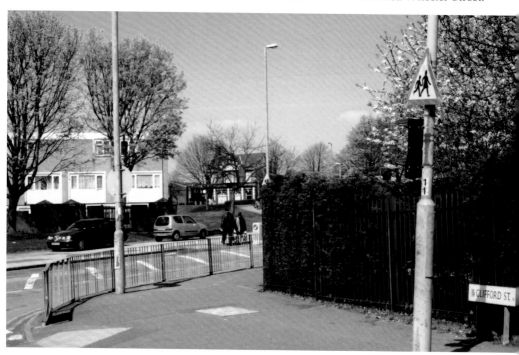

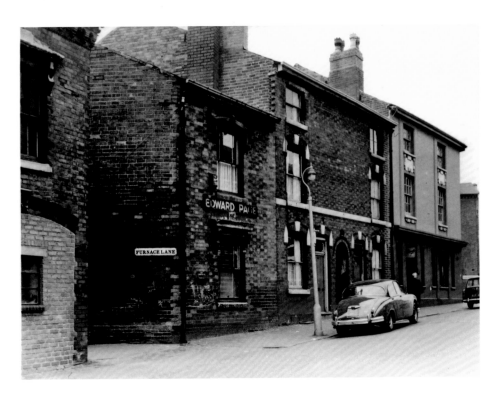

Furnace Lane

Furnace Lane cut its way alongside a warren of back-to-back and terrace housing; here it is leaving Clifford Street on the way to Porchester Street where it finishes. The lane was thought to be one of the oldest named thoroughfares in the area, the old furnace now lies under the new Yellow Park.

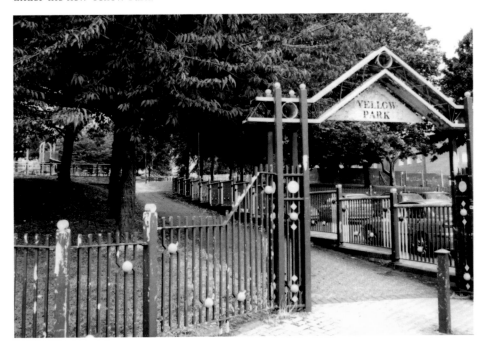

Gower Street

Furnace Lane appears again this time passing between John's transport café in Gower Street and a block of single story back-to-back houses. The approximate line of the old road is shown in the new photograph at the junction with Lozells Road.

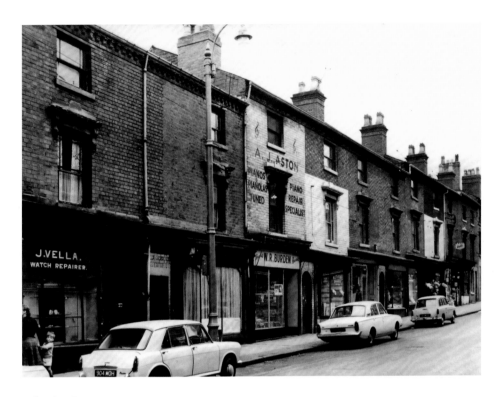

Wheeler Street

At one time Wheeler Street was a very busy shopping centre providing an array of goods for the thousands of families that lived and worked nearby. Redevelopment swept away the shops and provided an attractive tree-lined virtually traffic free environment.

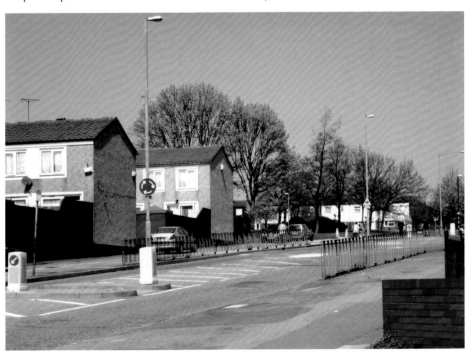

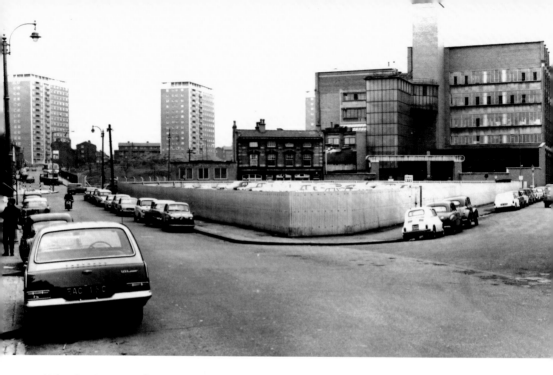

Wheeler Street and Farm Street

Wheeler Street just after the start of redevelopment in the 1960s is shown in the early photograph where Great King Street joins Wheeler Street. The Great King Street factory of Joseph Lucas on the right with a connecting overhead walkway is still operational at this time. Farm Street is the road passing the factory behind which two tower blocks are visible and they are still there in the 2010 photograph without the Lucas factory.

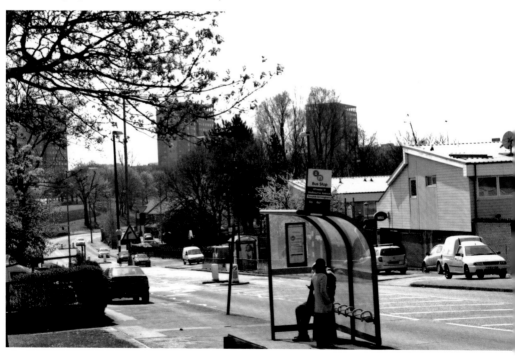

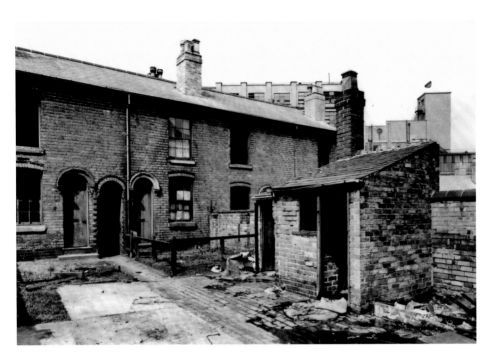

Remembering Lucas

There were several Joseph Lucas factories in the location around Farm Street one can be seen behind a derelict courtyard awaiting demolition. Fixed on the new wall of no 36L Wheeler Street is this large object of a wheel, a torch and a lion with the word Lucas, obviously letting the world know the Lucas Group once played a major part in this locality.

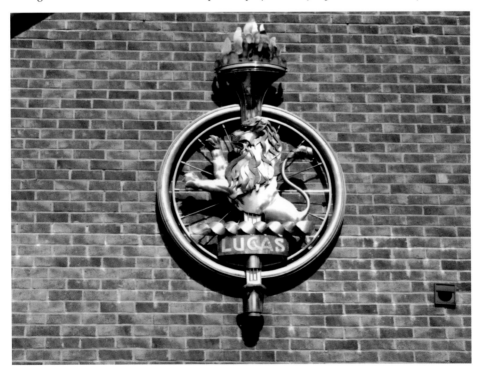

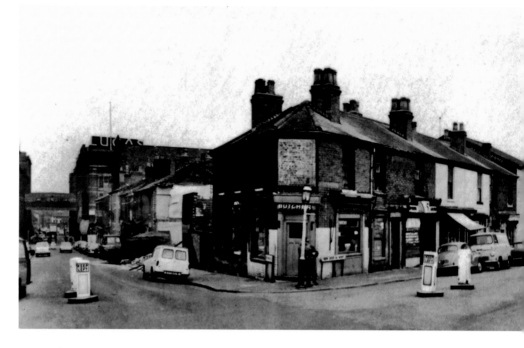

Great King Street

Lucas Great King Street was once the Birmingham headquarters of the Lucas electrical group. There were two buildings linked together by a walk-way many feet up in the air. Public transport buses lined this street at the end of the day shift taking thousands of the work force home across Birmingham and beyond. Approximately where the two buildings once stood a wide open green space has been created and two large stone memorials erected. One can be seen in the latest photograph between the two posts on the left.

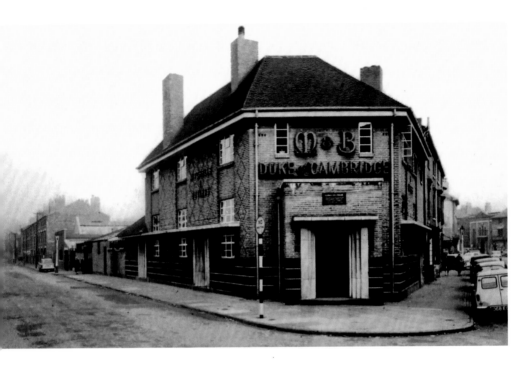

Duke of Cambridge

A well supported public house used by the locals and Lucas workers when it was open, the Duke of Cambridge closed and was demolished under the redevelopment that went on in the 1960/70s. Modern housing, high rise flats and a park with blue railings around now occupy this part of Hockley.

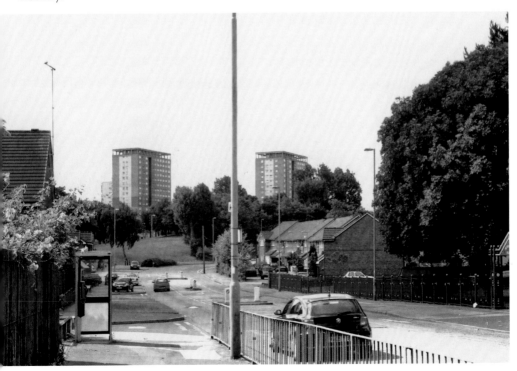

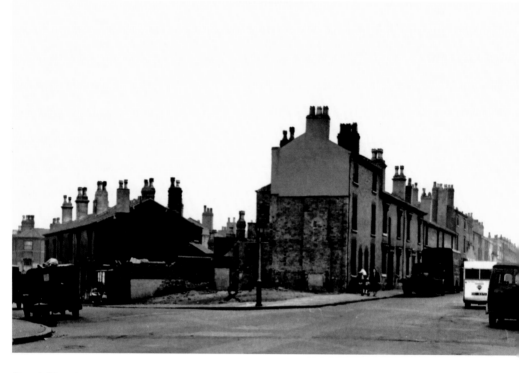

Guest Street

Another completely transformed street where, what looks very much like, a Second World War bombsite was created on one corner. With the rest of the old houses now demolished a peaceful outlook has been created with modern housing, green frontages with mature trees and a man to pick up any litter.

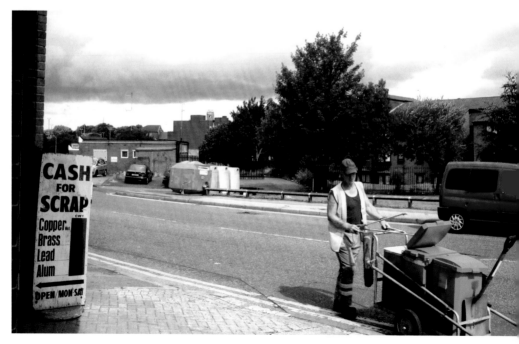

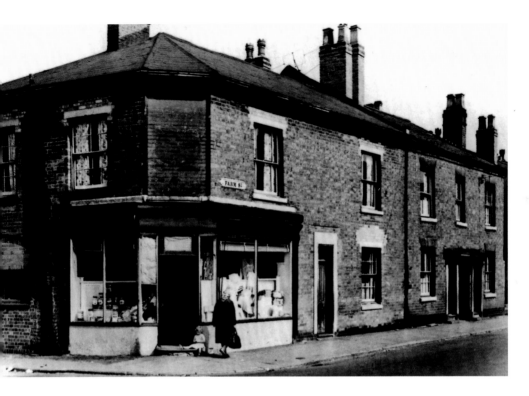

Farm Street

Farm Street was once a major through road from Hockley Brook to Aston but following redevelopment Farm Street was reduced in size, it now finishes at Wheeler Street. Traffic currently travels along New John Street West from the newly named Hockley Circus *en route* to Aston.

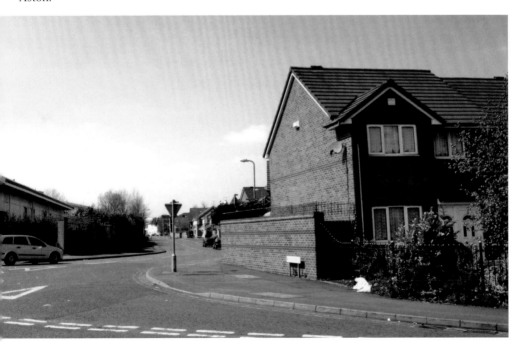

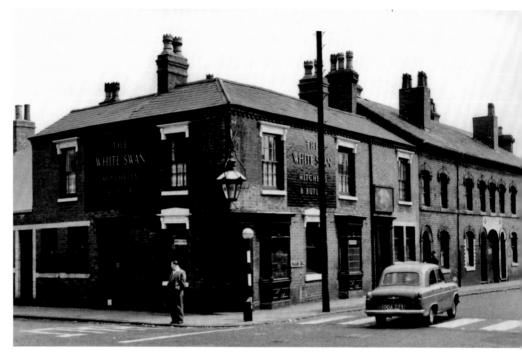

Farm Street and Villa Street

On the corner of Farm Street and Villa Street the local public house The White Swan once stood with back-to-back properties on one side and a factory on the other. Now modern houses occupy the site with a dental practice opposite.

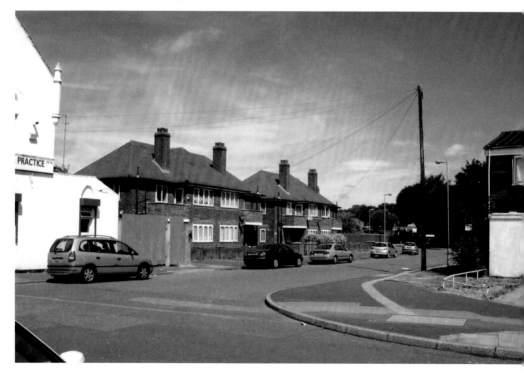

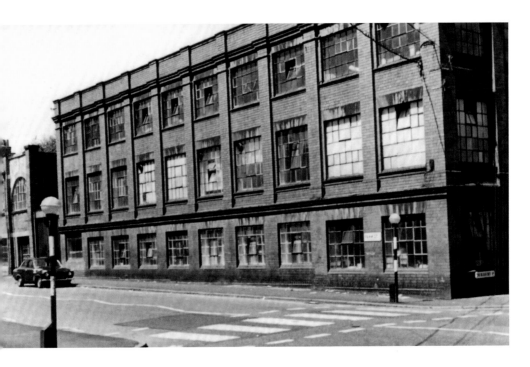

Burbury Park, Farm Street

Another factory, probably part of the Lucas group, stood on one corner of Farm Street and Burbury Street. Nearby was the Burbury Recreation Ground (the Rec.) a place where many generations of local children played. Now with the factory and the Rec. gone a new open green space entitled Burbury Park has emerged for the current and subsequent generations of local children to play in.

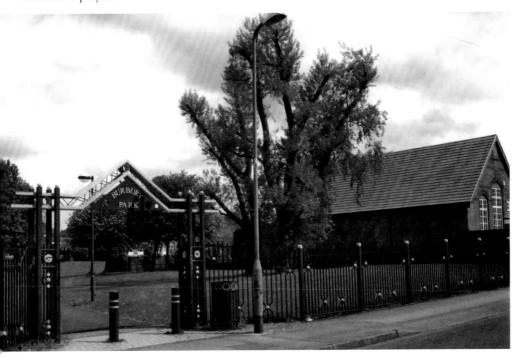

Two Locals

Having survived the bulldozers the attractive brickwork of one and the painted walls on the other public house stand out in stark contrast to the recently built homes that have replaced thousands of working class terrace houses that were there previously.

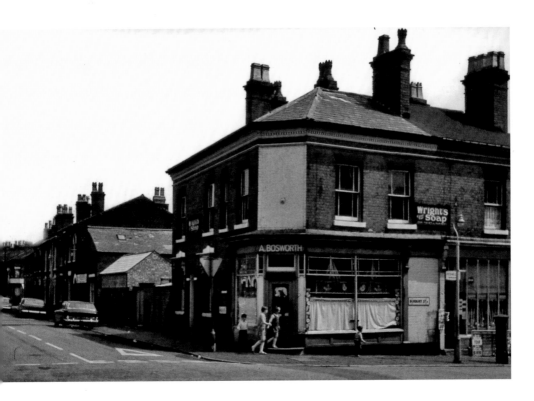

Wills Street and Burbury Street

Burbury Street Post Office is trading on both photographs where very little change has happened to the surrounding properties. Bosworth's old shop premises no longer displays the Wright's Coal Tar Soap advertisement since reverting to a domestic dwelling and cars now park on the footpath among the mature trees. The BT tower can be seen in the distance and an elevated satellite dish protrudes from a house to the left.

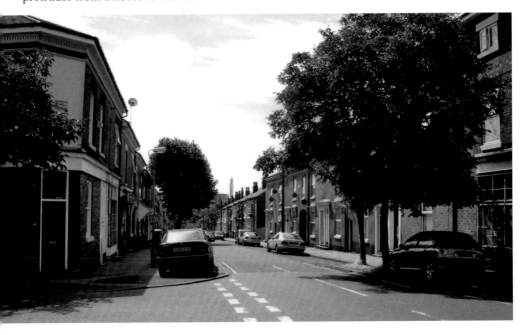

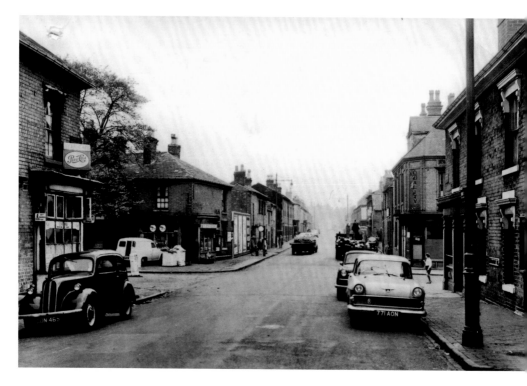

Nursery Road and Villa Street

The line of Nursery Road has not altered on both photographs, even the public transport bus stops remain in the same place although the new ones offer protection from the elements. Villa Street has become a cul-de-sac where newly-built homes plus an array of mature trees complete the new vista.

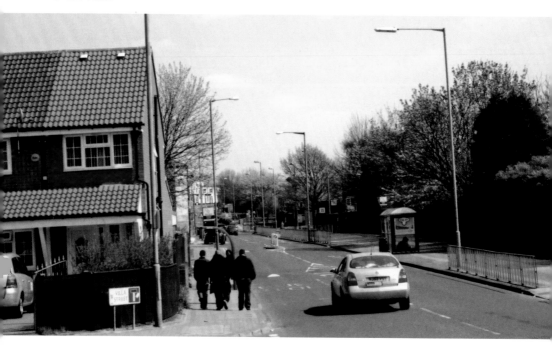

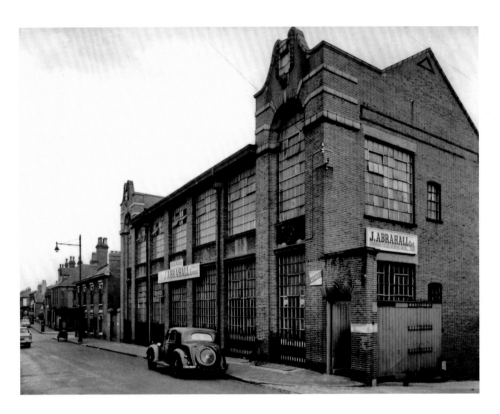

Nursery Road
Abrahall's old building remains but the houses beyond have been replaced with trees and
a green space. A row of neatly parked vehicles in the foreground must have been legally
parked for the community policeman to walk by towards Hunters Road.

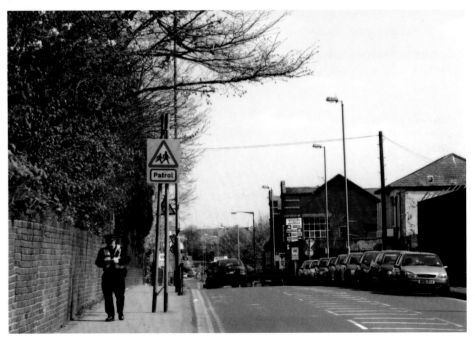

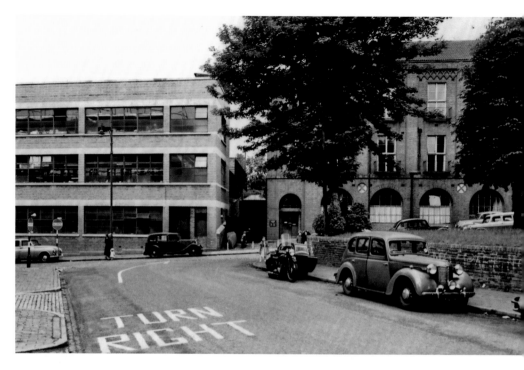

Hunters Road

Built into the fabric of this building on Hunters Road is, what appears to be, a shrine displaying a statue of a mother and child standing on a stone block that has the words 'The Carnegie Infant Welfare Institute' etched into the stone work. This building is unaltered and is part of today's National Health Service (NHS).

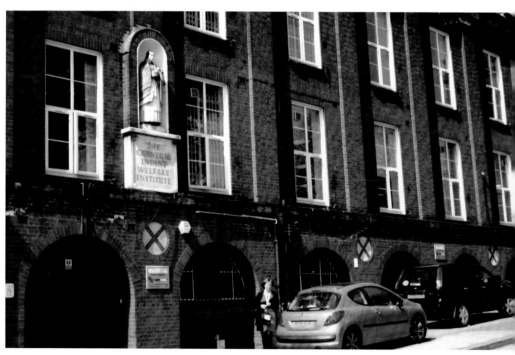

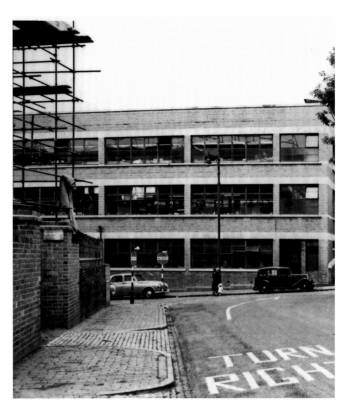

H. Samuels, Hunters Road
Down Hockley Hill
approximately one mile away
from the main Jewellery
Quarter is Hunters Road
home of the H. Samuels
jewellery factory seen here
in both photographs. Over
the years the building has
been added to, now a covered
walkway links the buildings
on either side of Hunters
Road.

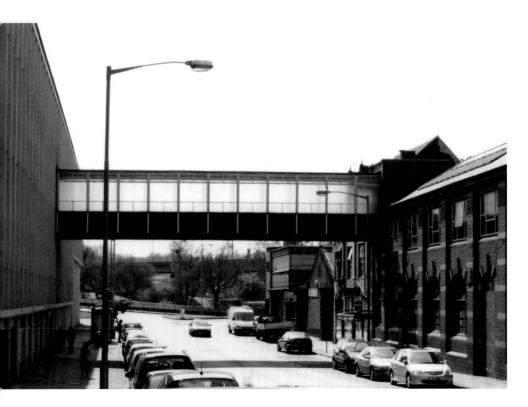

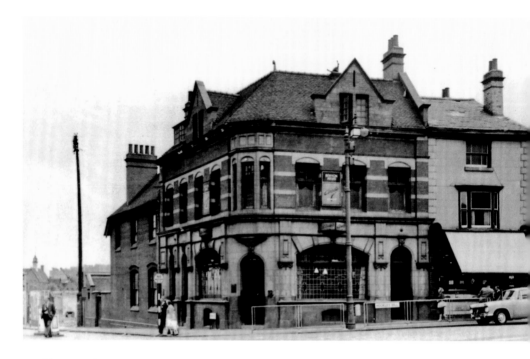

Hockley Brook

The culverted Hockley Brook passes through the bottoms of two hills at this point forming the boundary between Hockley and Handsworth. Traffic converging from five roads also met and passed through the junction. For centuries traffic in its various forms struggled to negotiate this very busy junction. The Benyon Arms on the corner of Hockley Hill and Farm Street was demolished as part of the modern solution to the traffic problem and a flyover road was constructed.

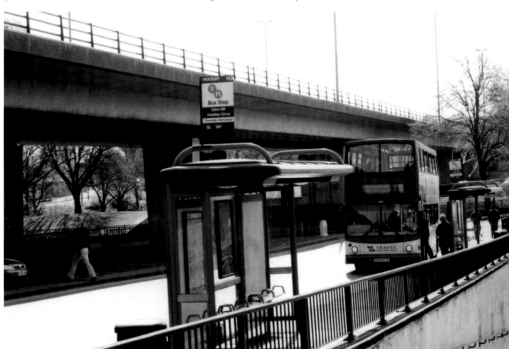

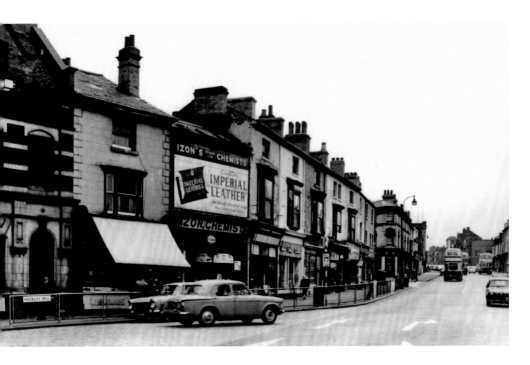

Hockley Brook Overpass

Shown in the early photograph is one of the hills that led from the Hockley Brook junction called Hockley Hill. This busy shopping centre now demolished eventually led to the centre of Birmingham. Traffic is now flowing smoothly from the Birmingham direction on the new Hockley Flyover in the 2010 image.

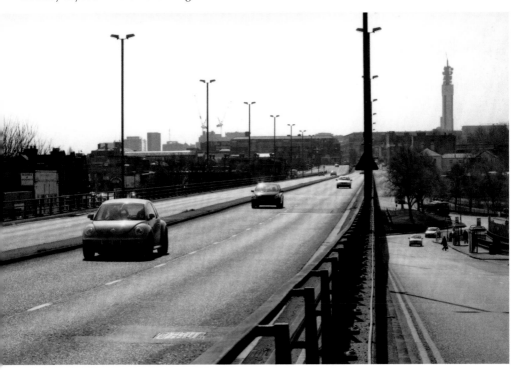

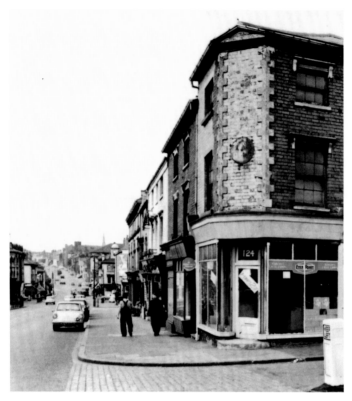

Hockley Brook Underpass
Hockley Hill from Birmingham, the Hockley Brook junction and Soho Hill appear in the early photograph and the modern route is shown in the later one. With the flyover came an underpass road and a pedestrian underpass with a mosque overlooking them all.

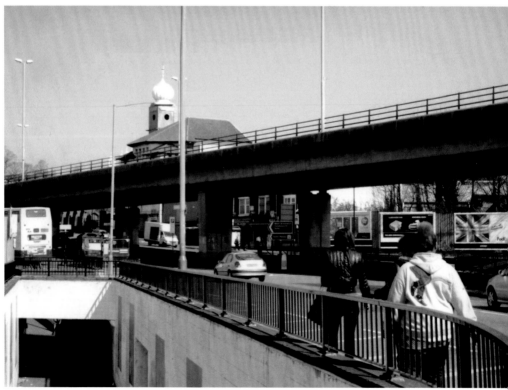

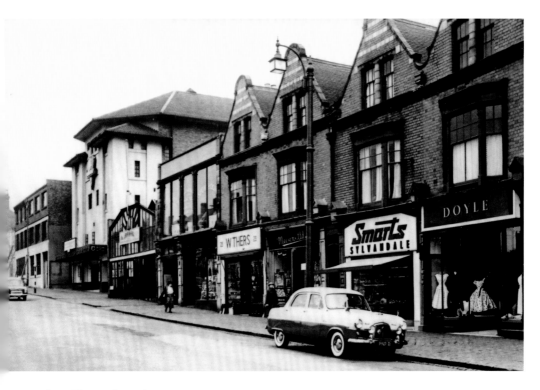

Soho Hill, Handsworh

Soho Hill is the road to Handsworth where at this point the Hockley Brook has just been crossed into Handsworth. A shopping centre that had many well-known shops lined one side of the hill. The white building at the end of the shops is a cinema called the Palladium, today the shops and cinema buildings obscured by the Hockley Flyover are still there but not trading.

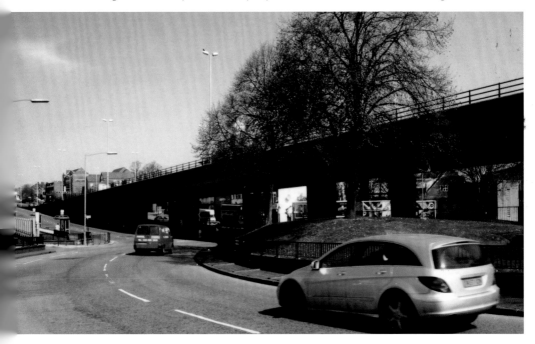

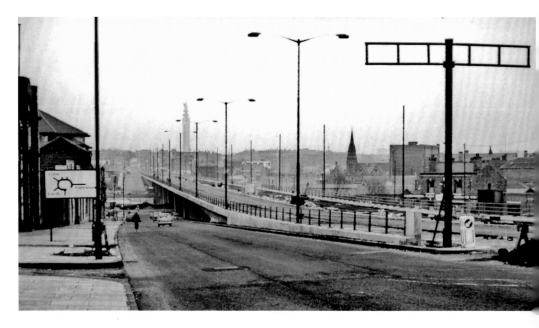

Top of Soho Hill (Handsworth)

In the distance views of Birmingham city centre dominate the sky line. Both photographs were taken from the top of Soho Hill at different stages of construction as the flyover was built.

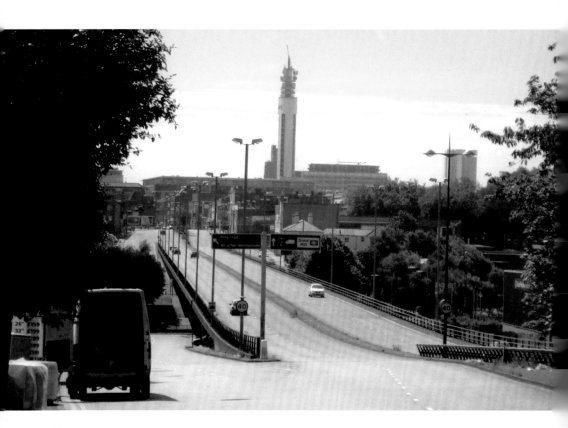

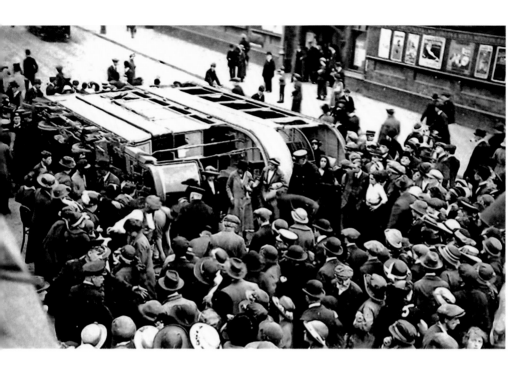

Soho Road (Handsworth)
After Soho Hill the road levels out into Soho Road where on the 26 June 1916 a tram overturned. Today at this location a large mosque has been built the Guru Nanak Nishkam Sewak Jatha at 18-20 Soho Road, Handsworth, Birmingham.

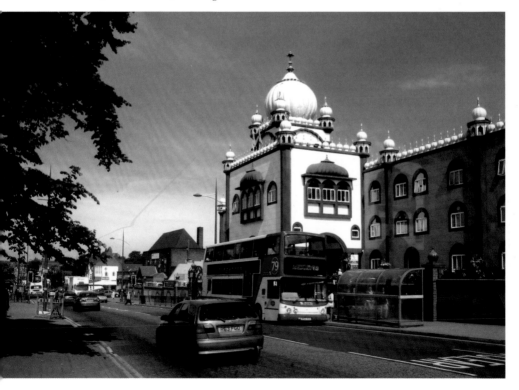

Factory Road

Another hill, St Michaels Hill, descends down from the Soho Road passing St Michaels Church then crossing the Hockley Brook back into Hockley where it becomes Factory Road. Although a large factory C. W. Cheney & Son Ltd exists in Factory Road the name derived from the original Soho Works of Mathew Boulton that once existed nearby from 1764-5.

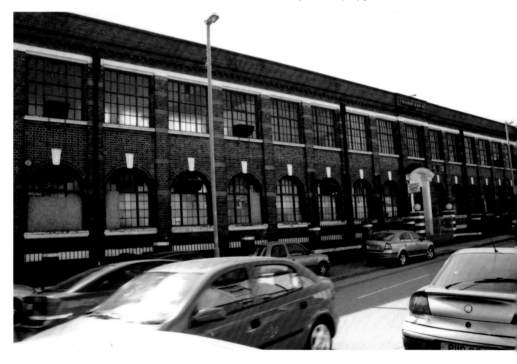

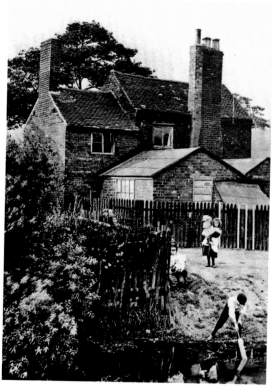

The Hockley Brook

After its source in Smethwick the Hockley Brook today is seldom seen due to man's intervention by culverting the stream. Two scenes over a century apart reveal the Hockley Brook flowing across Factory Road: one where children are playing and the other from the backyard of a car repair garage in Factory Road near Cheney's factory building.

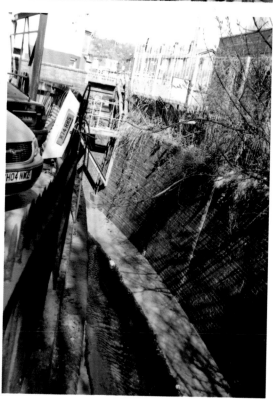

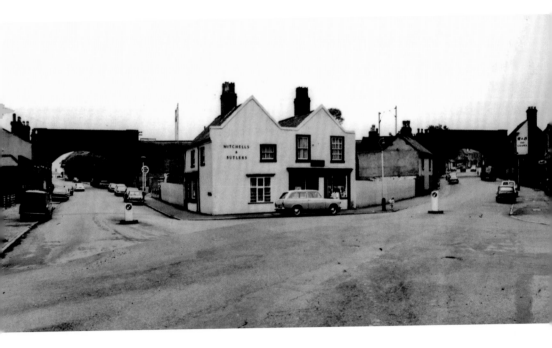

Crossroads of Three Districts

Both photographs were taken from Nineveh Road (Handsworth), to the right is Bacchus Road (Winson Green) and to the left Park Road where on its left is Gib Heath. The building central in the photographs has reverted from an off license to a house the rest appear unaltered.

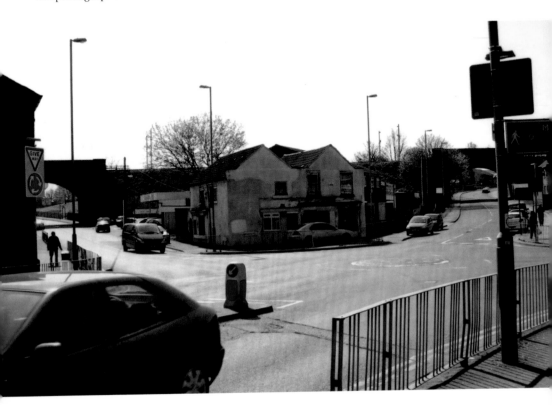

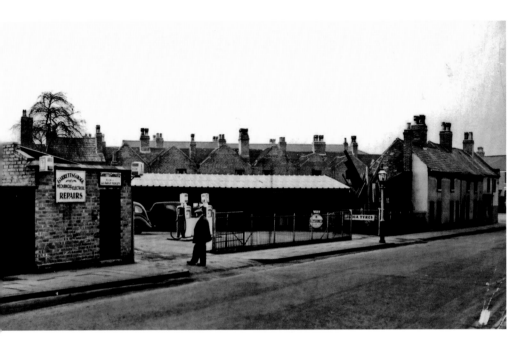

Park Road Garage

Garrets Garage in Park Road has changed ownership between the two photographs. The motorist's needs are now catered for by the Badwal Motors garage except for obtaining fuel which is no longer served from the forecourt. Houses at the back of the garages have also seen change with modern houses taking the place of the older ones.

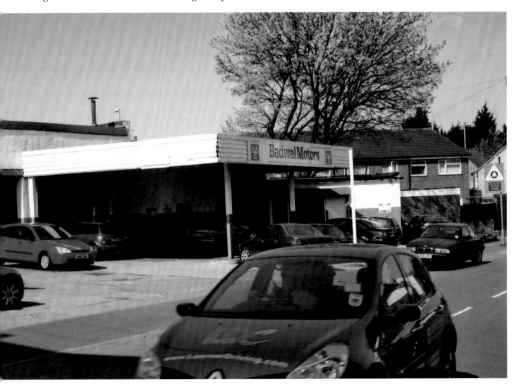

Park Road
Park Road just past Factory Road there is a bend in the road around which the older properties have been removed and replaced by an assortment of businesses.

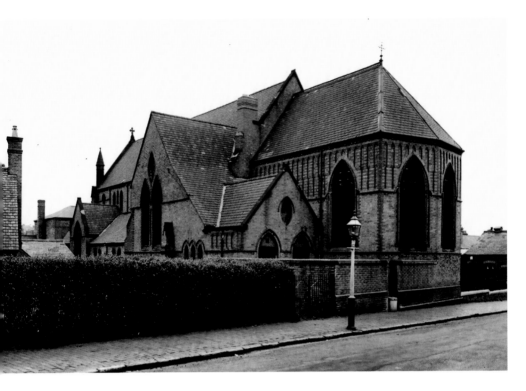

St Chrysostoms Church

A woodturning factory unit now occupies the site where St Chrysostoms Church once stood on the corners of Dover Street, Park Road and Musgrave Road. The church was built with the main entrance in Musgrave Road in 1888 and was finally demolished in 1970.

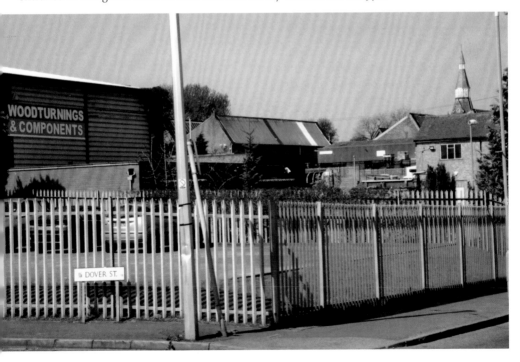

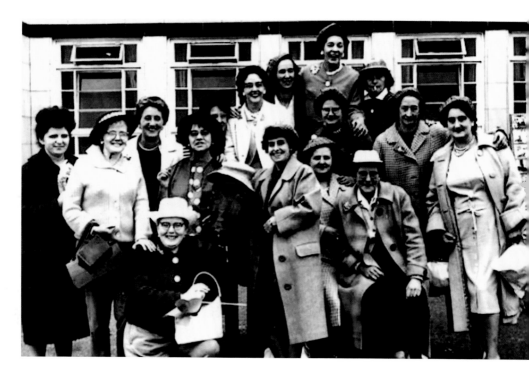

The Railway

Norton Street off Park Road is the boundary between Winson Green and Hockley where a railway runs a few yards from the public house once called the 'Railway Tavern' now simply referred to as 'The Railway'. Local ladies on a seaside day out from the pub appear to be enjoying themselves before returning to this well kept surviving drinking place.

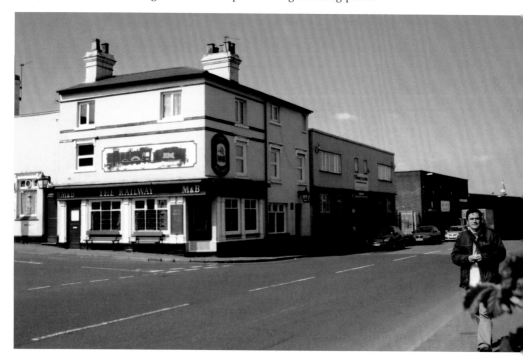

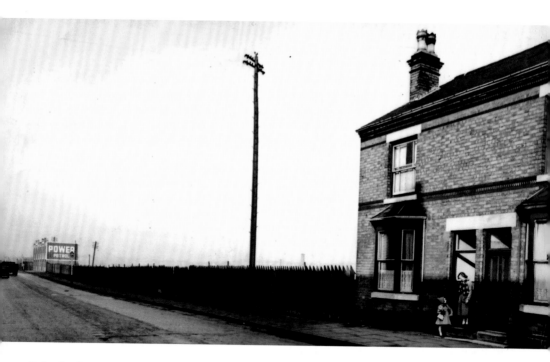

Soho Pool

Opposite Wharf Street and Wharf Lane on Park Road the houses abruptly end and a long row of wooden palings began. The land behind the palings and the houses for approximately one mile used to house railway lines, warehouses on a site called Soho Pool. Water has long been drained from the pool that once formed part of Mathew Boulton's landscaped garden attached to his Soho House.

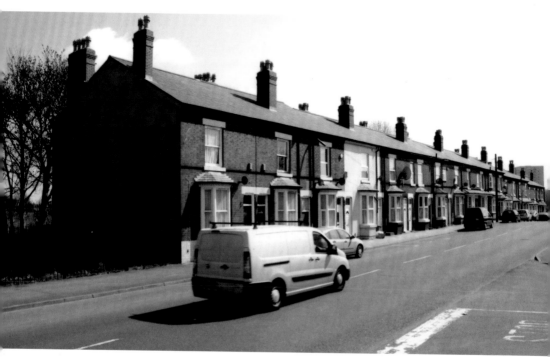

Soho Pool Green Open Space
Industrial warehouses that once occupied this large expanse of green open space half the length of Park Road have obviously been removed and the land landscaped. Views of Handsworth and towards Birmingham are a complete surprise and can be accessed via a pathway where the houses end opposite Wharf Lane.

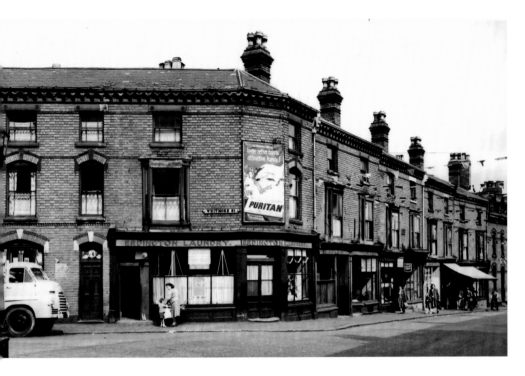

The New Bingley Hall

One end of Whitmore Street in the early photo came onto Park Road where a small row of shops began. The shops and all the houses in both roads that dated from the middle of the 1800s were demolished in the 1960/70s. Only the old Birmingham Corporation tram/bus garage building in Whitmore Street remains and this has been incorporated as part of a new building housing a conference centre entitled 'The New Bingley Hall'.

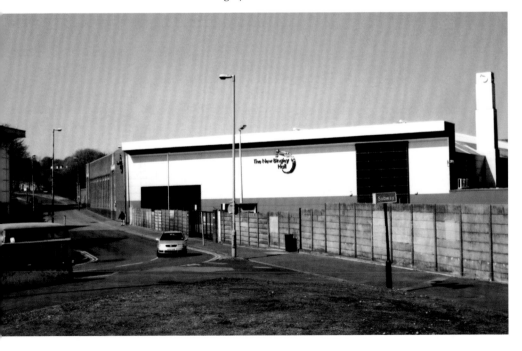

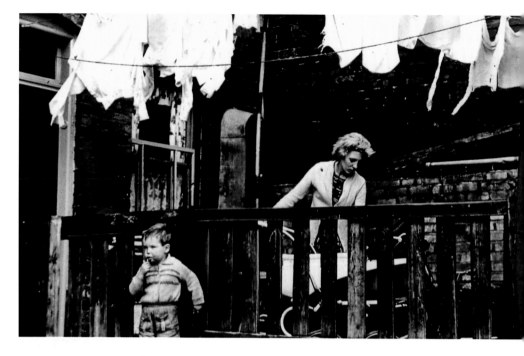

Heaton Street Back-to-Backs

Washing on the line, tin bath on the outside wall, mother attending her new baby in a pram and a young boy on the other side of the home made palings in Heaton Street Hockley encapsulates the back-to-back living most families in the inner city districts of Birmingham experienced. Alterations in the traffic flow at the lower end of Icknield Street have brought a high volume of vehicles down modern Heaton Street.

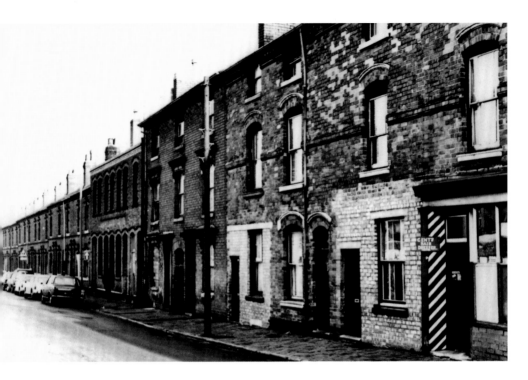

Heaton Street

Built over 100 years before side by side with factories the working class housing in Heaton Street in the 1960s are showing signs of major repairs where large amounts of brick work has been replaced around the door and window frames. Modernisation locally has left this street unrecognisable.

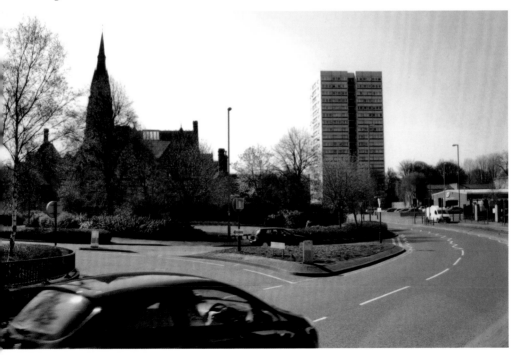

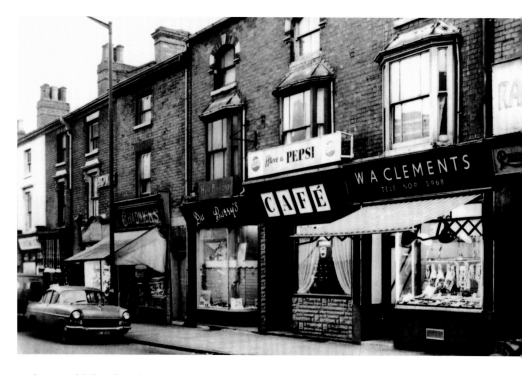

Lodge Road (The Flat Shopping Centre)

For over one hundred years the large variety of shops offered in this shopping centre on Lodge Road attracted plenty of shoppers from many surrounding districts. Now due to the redevelopment of this area half the shops and the road has been demolished. And now most of the remaining properties provide a range of takeaway food.

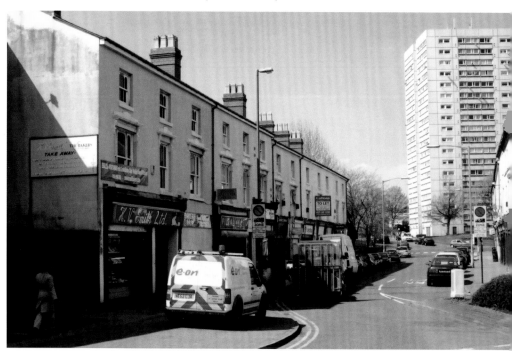

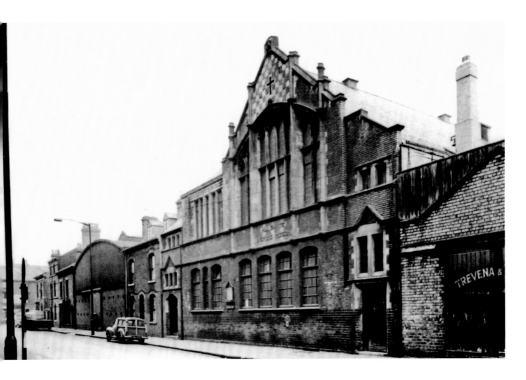

Simon's Mission

As the population increased after 1850 All Saints Church set up a large number of subsidiary missions in the parish one was St Simon's Mission in Heaton Street. Built with factories either side among the many old houses from the same period the mission building remained until redevelopment removed it. Today religion is provided for through two mosques one newly built across the Hockley Brook and the other in the old Icknield Street School shown in the background of the Heaton Street 2010 photograph.

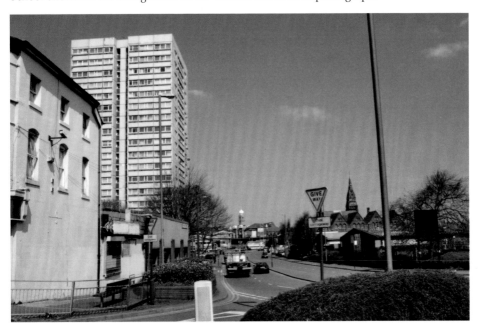

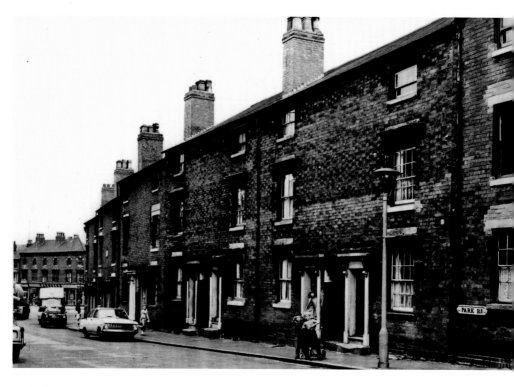

End of Park Road

Two views taken at the end of Park Road demonstrates the redevelopment this part of Hockley underwent. New houses with gardens and garages, grass verges and trees have been provided, replacing the attic high terraced housing from another era.

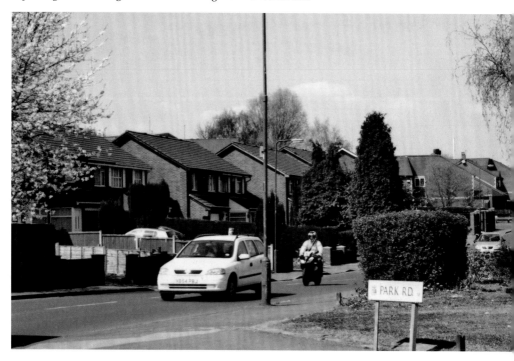

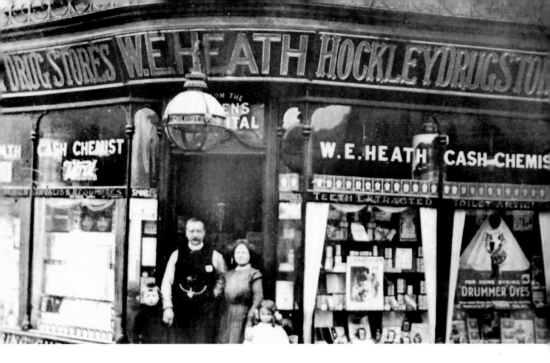

Ford Street and Lodge Road

Standing proudly in the doorway of the Hockley Drug Store presumably this family is the same as the name displayed above. Same building now Mills Wine Store is still standing on the corner of Ford Street and Lodge Road a stone plaque on this row of shops reveals they are the Abbey Buildings 1869. Note W. E. Heath was a cash chemist a reference to not allowing credit, however most shopkeepers in the back street did allowed credit at this period. Another window sign informs he was also able to extract teeth.

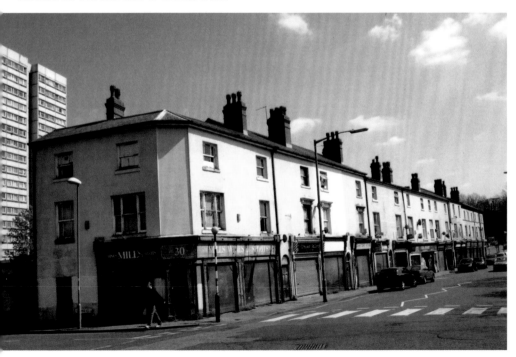

Icknield Street

The horse and cart is travelling along the lower end of Icknield Street just before the Hockley Brook and immediately after the point where Lodge Road faces Key Hill with Norton's department store on the corner. Lodge Road to the right was a shopping area known locally as The Flat so named because there are hills either side. Now a dual carriageway with a landscaped traffic island exists at this crossroad.

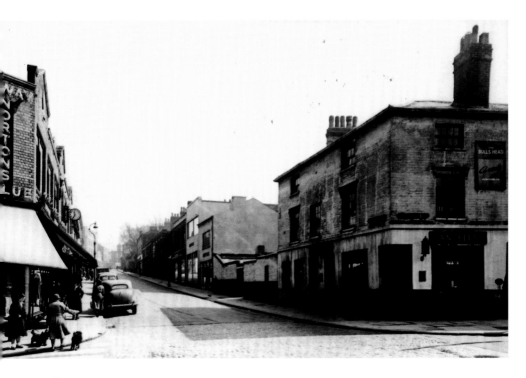

Key Hill

Built on land that once contained gardens and a productive sandpit the Key Hill Cemetery opened in 1835 then called the General Cemetery. Location of Hockley's oldest cemetery is on the right towards the top of each photograph. Ironically redevelopment has brought a rural aspect back to Key Hill.

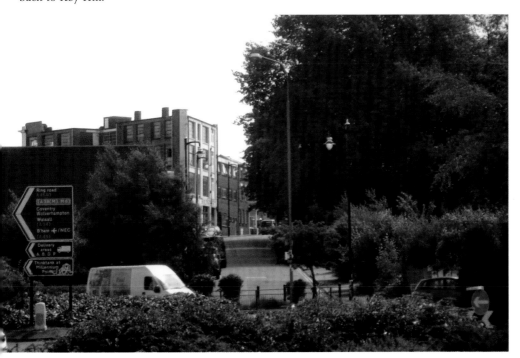

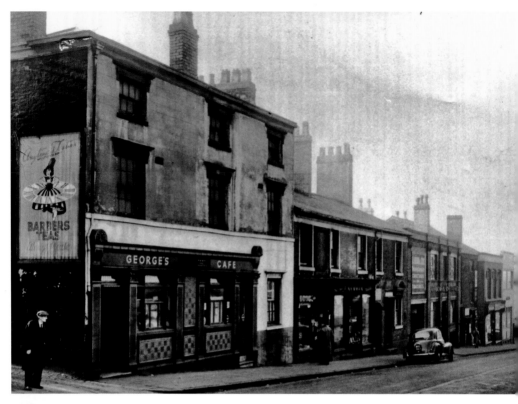

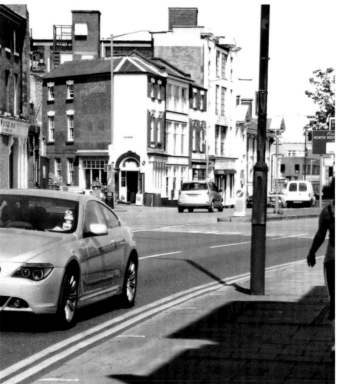

Key Hill Shops

From the Icknield Street end two large department stores "Nortons" (By-Way Value) and A. & C. Timms were among the many shops on both sides of Key Hill. George's Café was the last premises before the cemetery. The other end of Key Hill was accessed from Hockley Hill where the buildings remain largely as built.

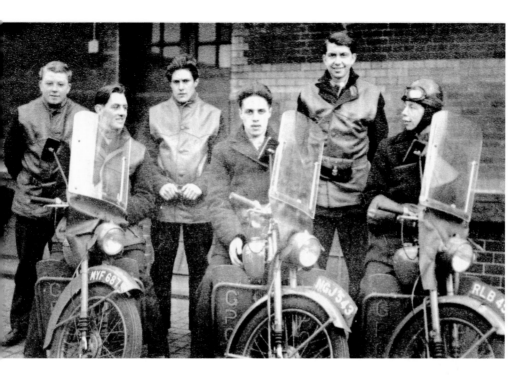

Hockley Post Office

Access to the front office/counter of Hockley Post Office is still on Hockley Hill at the rear the main sorting office and yard is accessed from Key Hill. Post Office telegraph messengers known as WAGS (an old term from the past) are assembled in the yard in 1958 with their BSA bantam motor bikes. Back row left-right A. Goddard, J. Hunt and A. Marshall. Front row, D. Steadman, Ted Rudge, co-author of this book and R. Pestridge.

Key Hill Cemetery

Two views of Icknield Street more than sixty years apart with the Key Hill end of Key Hill cemetery in both. A dual carriageway brings the traffic up and down this road now where a Tesco garage is available. The old houses were removed under the redevelopment scheme.

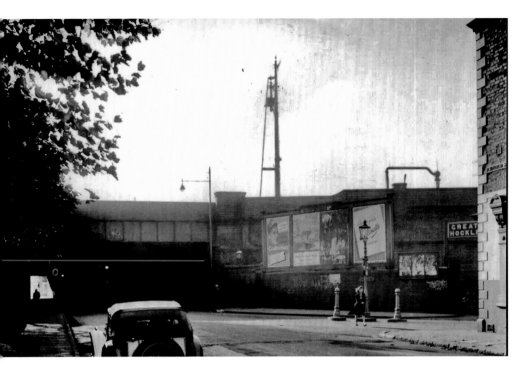

Icknield Street Railway Bridge

A walk under this long dark depressing tunnel with the old railway bridge above often broke into an Olympic sprint along Icknield Street especially at night. Key Hill cemetery was one side and Warstone Lane cemetery on the other. Now a modern bridge does not generate the same thoughts and sounds as before.

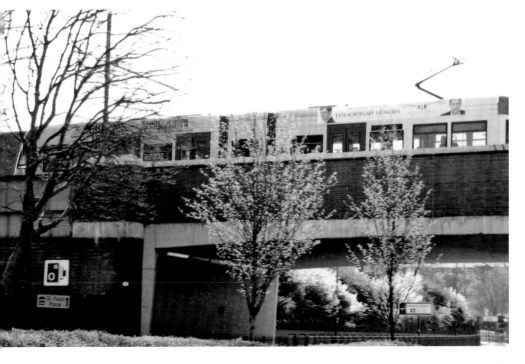

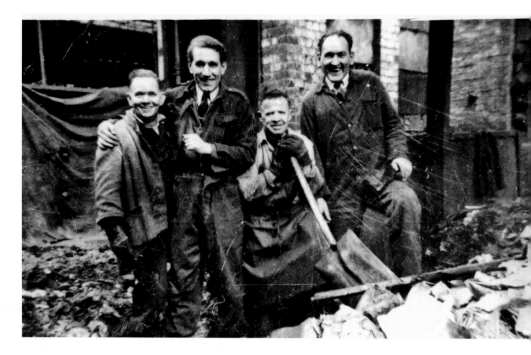

The Mint Icknield Street

In 1860 Ralph Heaton and Son moved their business to a site on Icknield Street, Hockley near the Jewellery Quarter this became the Birmingham Mint. Among the four workers photographed during a break from their jobs at the Mint was Fred Boaz the man holding the shovel, he was a Brass Caster, who lived across the road from the Mint in Icknield Street. The others were employed around the large furnaces that melted the metal in the production of coins and other items. In the other photograph cobble stones are seen as Pitsford Street meets Icknield Street this is then followed by Warstone Lane cemetery with the Birmingham Mint at the end, note the Mints large chimney at the far left.

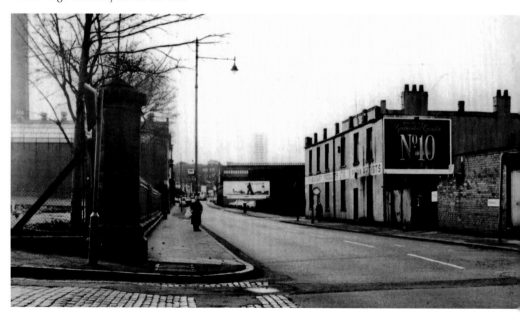

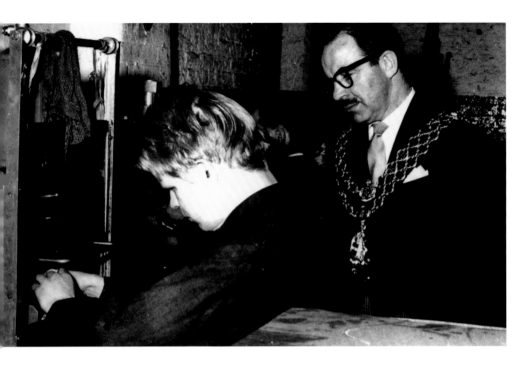

Lord Mayor at the Mint
On an official visit to the Birmingham Mint, Frank Price, Lord Mayor of Birmingham 1964/5 is seen looking interestingly at one of the many products the Mint produces. Keith Archer from Devonshire Street, Winson Green was inspecting a brass elbow during the visit. Birmingham Mint has closed and the building is currently undergoing refurbishment when the 2010 photograph was taken.

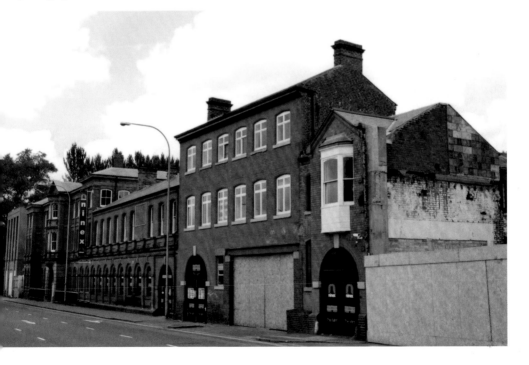

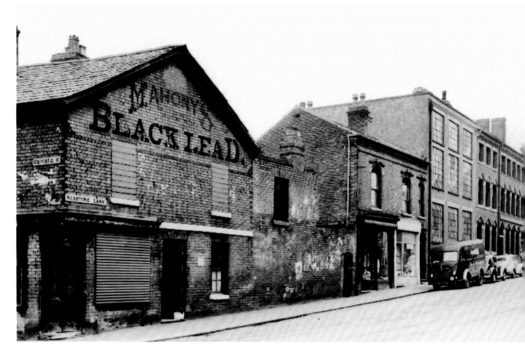

Icknield Street and Warstone Lane Corner
A liquid product used to polish the surrounds of a coal burning domestic fire place called Black Lead is advertised above the boarded up building on the corner of Icknield Street and Warstone Lane. A lighting showroom now occupies this corner that leads to the Jewellery Quarter.

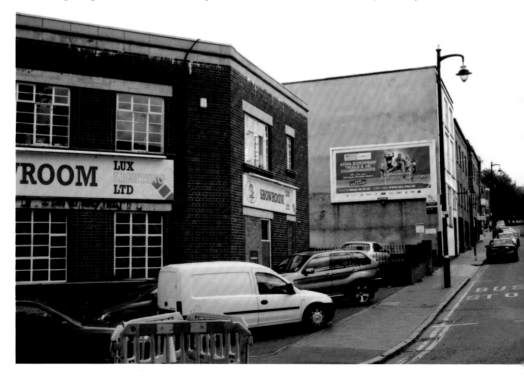

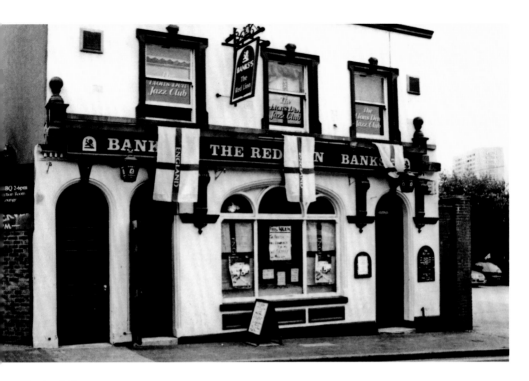

The Red Lion

Externally The Red Lion public house shows no sign of alteration over the period of the two photographs. However change on either side of The Red Lion has begun with large scale construction work creating an urban village that will change this part of Warstone Lane in the very near future.

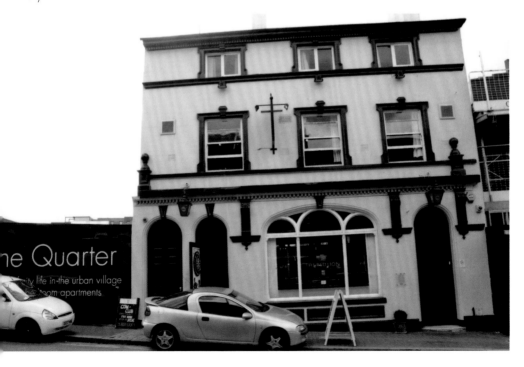

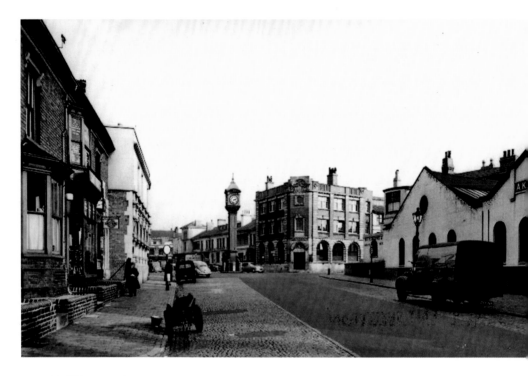

Up Warstone Lane

Warstone Lane is shown facing up the hill towards the Chamberlain memorial clock where the road surface shows a legacy of the horse and cart transport period by still being cobbled. A window cleaner's cart and ladders occupies part of the traffic free road and a bucket is left on the pavement. By 2010 the traffic has increased with parking restrictions imposed on both sides and the trees from the cemetery grounds are hanging over.

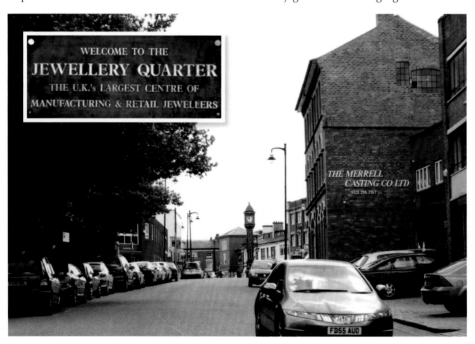

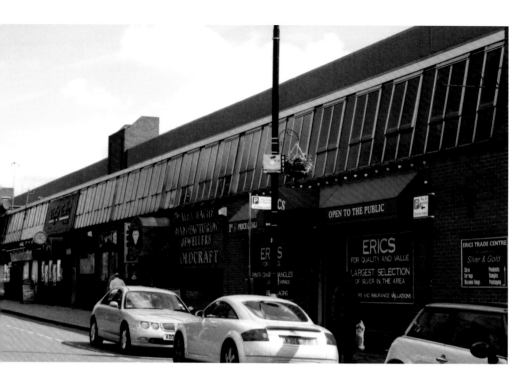

Vyse Street

On both sides of Vyse Street many of the old properties have been demolished to make way for the Big Peg and numerous new jewellery retail and manufacturing outlets. They trade alongside those that are still housed in the converted original properties. Another recently new addition to the street is the Jewellery Quarter Train Station this opened in 1995 next to the green Victorian structure that has been a relief to many men.

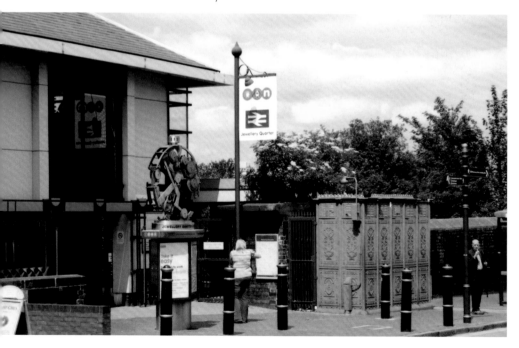

Acknowledgments

The authors of *Hockley Through Time*
Ted Rudge (www.winsongreentobrookfields.co.uk) and John Houghton (www.astonbrook-through-astonmanor.co.uk) have both had their own Birmingham local history web sites since 2002 dedicated to preserving the memories of their readers. Memorabilia of various kinds mainly in the form of emails, letters or photographs are donated begged or borrowed by Ted and John for inclusion on their sites. However the completion of this book has been made possible by the generosity in time and materials from many people and if any are missed in this acknowledgment we apologise.

Thank you to the following people and web sites who have helped in this project.
Professor Carl Chinn; http://lives.bgfl.org/carlchinn
For allowing us to use photographs from the "Carl Chinn Archive" and for writing the foreword to this book.
Mac Joseph who provided certain Hockley post cards and photographs from his private collection
Beryl Evans for the use of her Summer Lane photographs and advise. Jean Bytheway for the use of a personal Birmingham Mint photograph from her family album. Keith Archer for the Birmingham Lord Mayor photograph and more.
And to all the people who contributed from the John Houghton and Ted Rudge websites. To Ted's wife Maureen for proofreading the text and providing encouragement with the project. And to John's wife June for accompanying him on the photographic visits and making notes used in the captions.

Michael Ingram www.astonbrook-through-astonmanor.co.uk
Birmingham History forum http://birminghamandsuburbs.com/forum/ whose members help keep Birmingham's history alive.

We would also like to thank Amberley Publishing for given us the opportunity to produce this local history book describing some of the changes, mainly environmental, displayed in *Hockley Through Time* and to everyone who reads the book we trust it rekindles memories the way it was or still is for you.

Ted Rudge MA and John Houghton

* * * * * * * * * * * * * *

Other Birmingham Through Time Amberley Publications

Winson Green to Brookfields Through Time by Ted Rudge
In and Around Ladywood Through Time by Ted Rudge
In and Around Aston Through Time by Ted Rudge & John Houghton
Birmingham Up Town Through Time by Ted Rudge, Mac Joseph & John Houghton
Small Heath & Sparkbrook Through Time by Ted Rudge & Keith Clenton